Figure It Out!
FACES & EXPRESSIONS

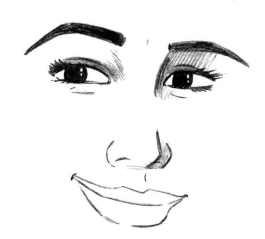

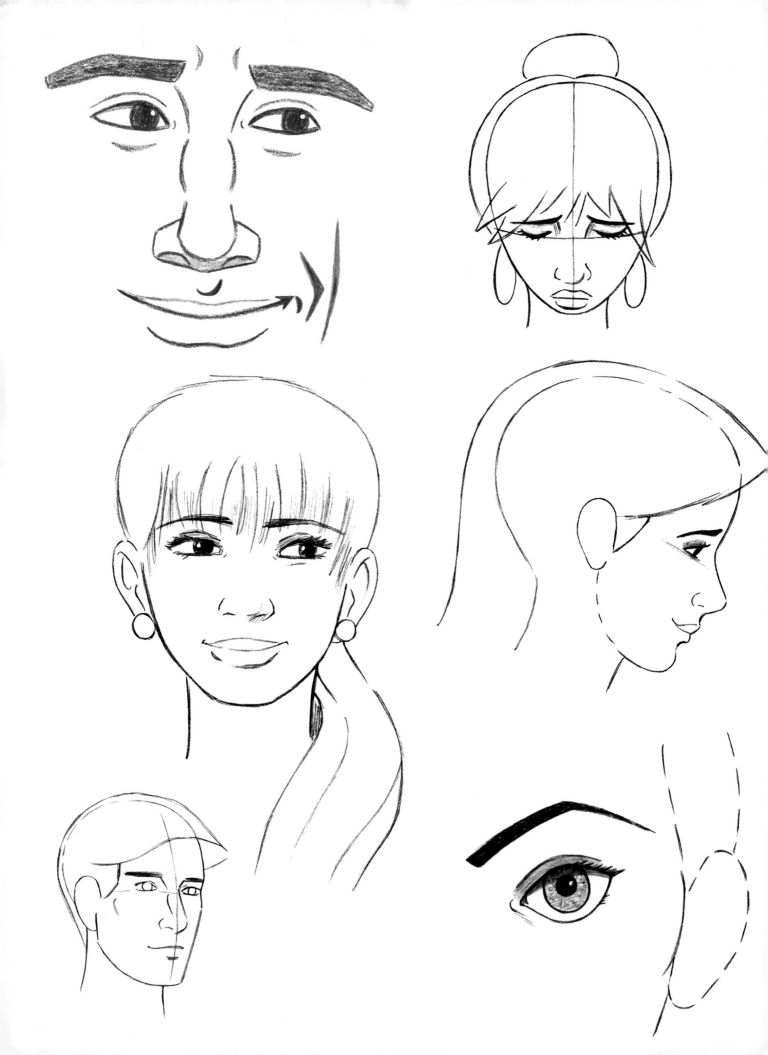

Figure It Out!
FACES & EXPRESSIONS
The Ultimate Drawing Guide for the Beginning Artist

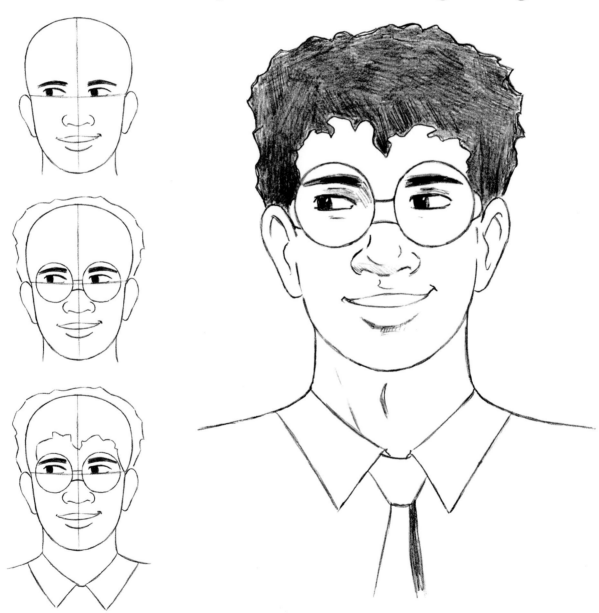

 Get Creative 6

DRAWING WITH *Christopher Hart*

An imprint of **Get Creative 6**
19 West 21st Street, Suite 601, New York, NY 10010
sixthandspringbooks.com

Senior Editor
MICHELLE BREDESON

Art Director
IRENE LEDWITH

Chief Executive Officer
CAROLINE KILMER

President
ART JOINNIDES

Chairman
JAY STEIN

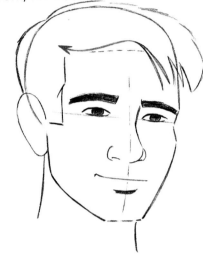

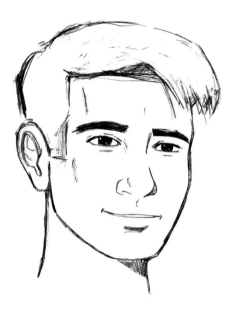

Library of Congress Cataloging-in-Publication Data

Names: Hart, Christopher, 1957- author.
Title: Faces & expressions : the ultimate drawing guide for the beginning artist / Christopher Hart.
Other titles: Faces and expressions
Description: New York : Drawing with Christopher Hart, [2021] | Series: Figure it out! | Includes index.
Identifiers: LCCN 2021030224 | ISBN 9781684620357 (paperback)
Subjects: LCSH: Face in art. | Facial expression in art. | CYAC: Drawing--Technique. | BISAC: ART / Techniques / Drawing | ART / Subjects & Themes / Human Figure
Classification: LCC NC770 .H367 2021 | DDC 743.4/2--dc23
LC record available at https://lccn.loc.gov/2021030224

Manufactured in China

3 5 7 9 10 8 6 4 2

First Edition

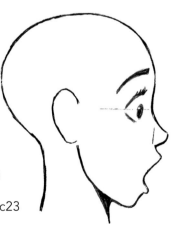

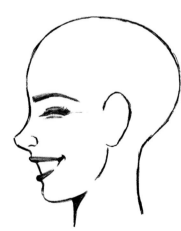

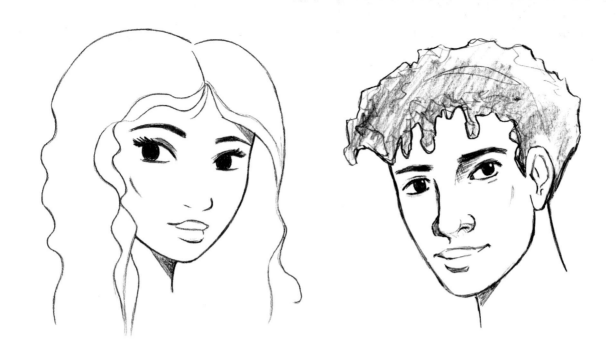

For Maria, Isabella, and Francesca

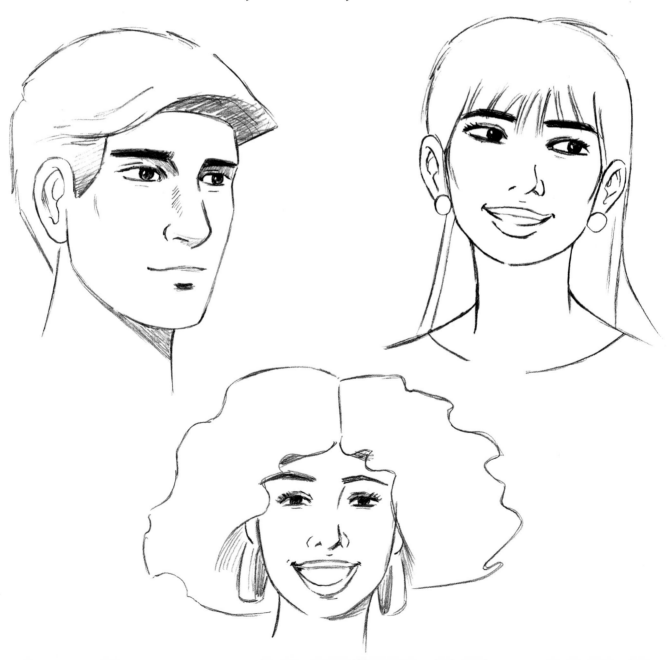

Contents

Introduction

This new book is one of the most important titles in my *Figure It Out* book series. Almost everyone who learns to draw starts out by drawing faces. Faces are interesting, varied, and expressive. And this book is the place to start. You'll get solid, practical tips and techniques so you won't develop bad habits you might have to unlearn later. The step-by-step lessons in this book will show you how to draw the head at different angles and with different emotions and expressions. You'll learn how to draw eyes and the other features. I'll also show you the how and why for using shading techniques. Finally, there's a big chapter that demonstrates how to craft hairstyles to suit your character type. With this book, you can quickly improve your drawing skills with instruction that's clear and easy to follow. It's a complete course at your fingertips.

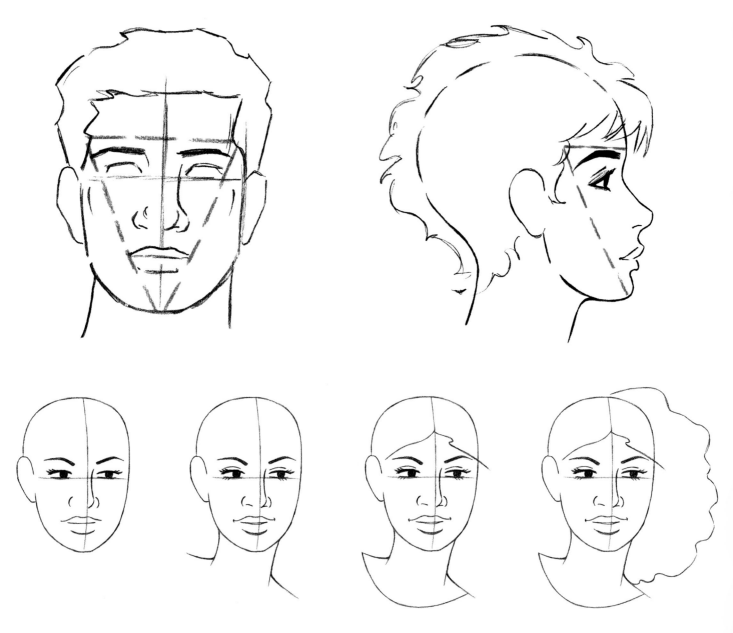

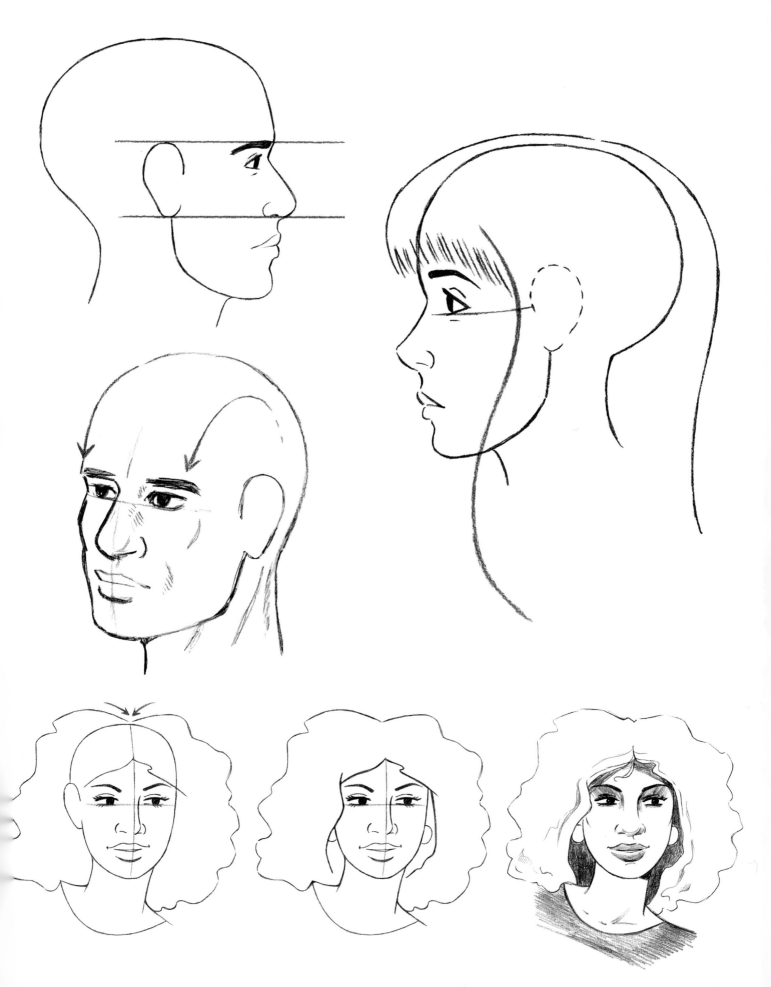

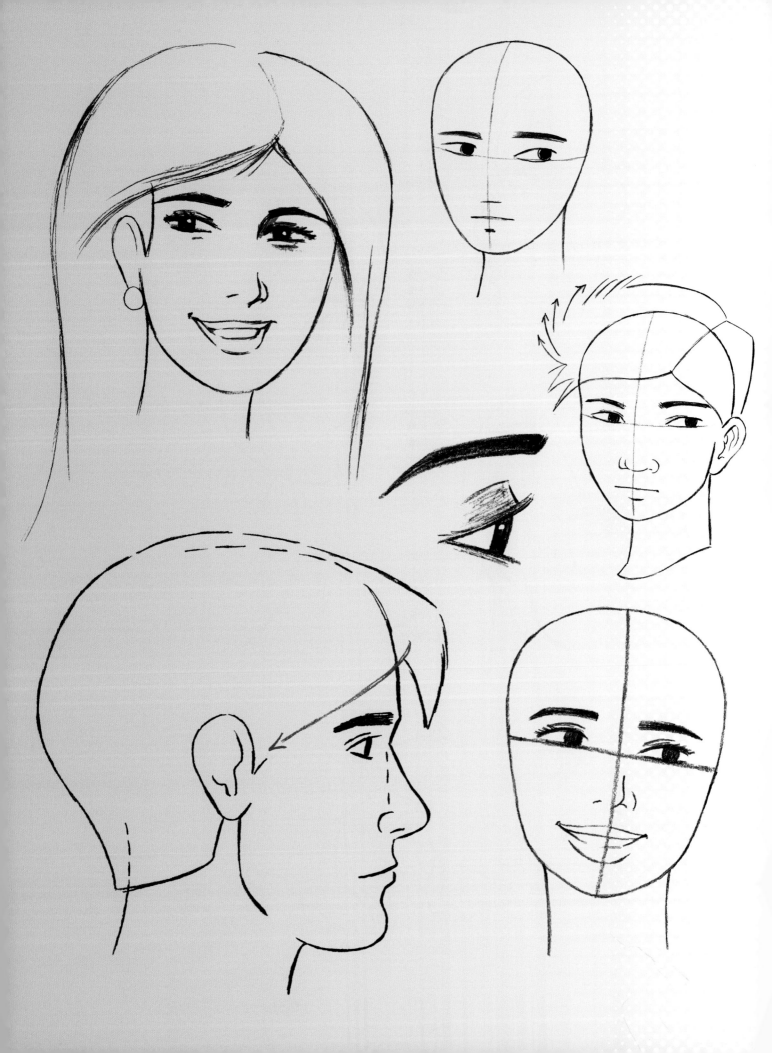

Build a Strong Foundation

Proportions in the human face represent the spatial relationships between the features. They're consistent and change little between people. They are incredibly useful because they allow us to check and correct our work when it looks off. In this first chapter, we'll look at some of the most important proportions and other principles that will help you draw faces accurately. Once you have a firm foundation, you can have fun creating individual characters. Let's get started!

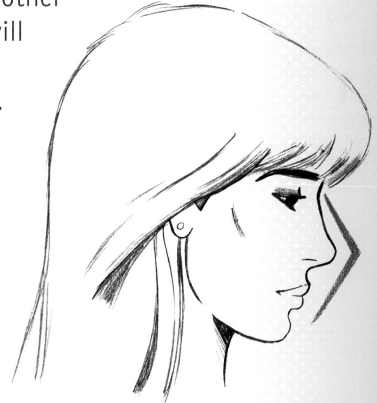

The Most Important Proportion

The entire face is constructed around one proportion. It's also the easiest proportion to remember. Here it is: *The eyes are drawn at the center of the head, as measured from top to bottom.*

Many people believe the eyes are closer to the top of the head than they are to the middle. This common misconception creates problems when you begin to add the other features. Let's put this proportion to the test and see if it's correct.

Right!

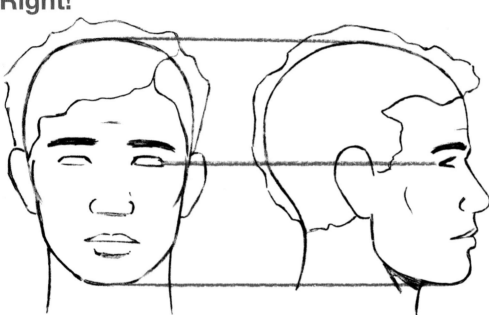

Set in the center of the head, the eyes look right.

Wrong!

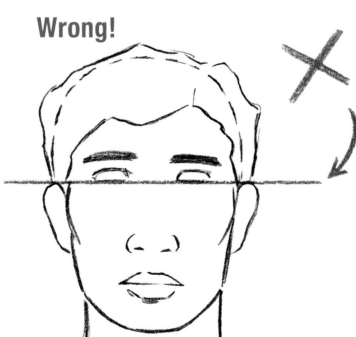

By moving the eyes just a notch above center, they look awkward and throw everything off.

Practicing the Concept

Let's use the center-of-the-head eye proportion as the starting point for drawing the face. We'll go step by step.

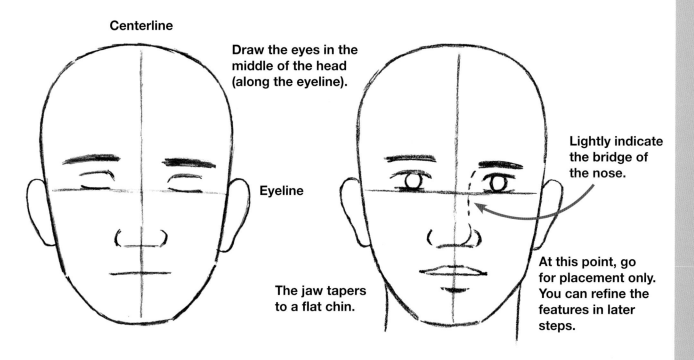

Centerline

Draw the eyes in the middle of the head (along the eyeline).

Eyeline

The jaw tapers to a flat chin.

Lightly indicate the bridge of the nose.

At this point, go for placement only. You can refine the features in later steps.

We sometimes draw eyes too large because of the emotional emphasis we place on them. Keep them on the smaller side.

Once the hair is sketched in, the character begins to reveal itself.

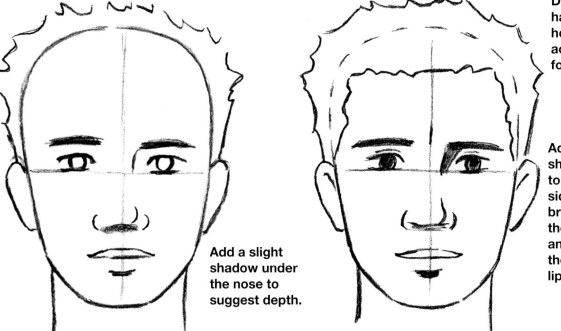

Add a slight shadow under the nose to suggest depth.

Draw the hairline horizontally across the forehead.

Add shadows to the side of the bridge of the nose and under the lower lip.

Rough Sketch

The rough sketch informs us of how the final step should look. But you're not locked into it. If you begin to deviate from the rough, go with it.

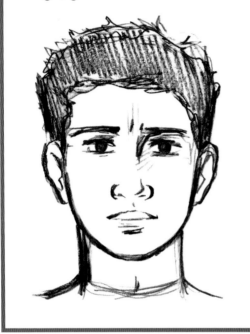

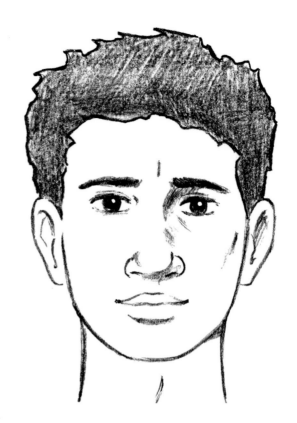

I drew the final version with open, less troubled eyes and a slight smile. It's very close to the sketch, but more pleasing, in my opinion.

More Guidelines

Here are two more useful guidelines for placing the eyes.

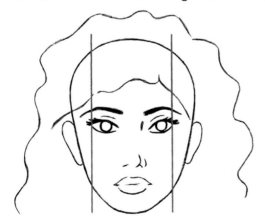

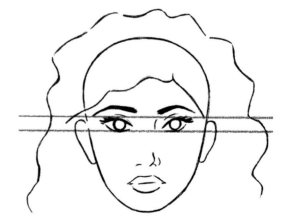

The distance from the corner of the eye to the edge of the face should be the same on both sides.

Adding a second parallel guideline above the first will help keep the eyes the same size.

Keeping It Simple

In this book, I'll be introducing a lot of new techniques. If you get stuck, remember to simplify. Professional artists don't make simple things look complicated. They make complicated things look good by simplifying them.

Centerline

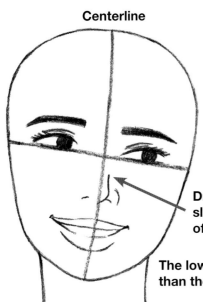

Decide where the part will be, and let the rest of the hairstyle flow from it.

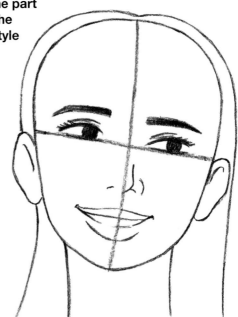

Align the eyes on the horizontal eyeline.

Draw the bridge slightly to one side of the centerline.

The lower lip is thicker than the upper lip.

FACE FACTS

When the head is slightly tilted, the eyeline and centerline should also tilt slightly. This will keep the features aligned.

Draw random, brushy bangs over the forehead. Too much control looks stiff.

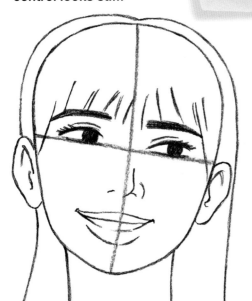

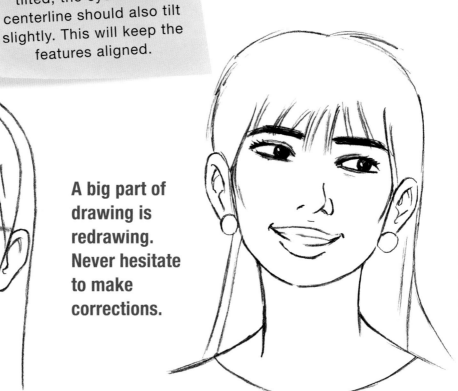

A big part of drawing is redrawing. Never hesitate to make corrections.

Hidden Proportions

Some proportions aren't obvious. Here's one you might not know, which is especially important for drawing profiles: *The top of the ear lines up with the eyebrow, and the bottom of the ear lines up with the bottom of the nose.*

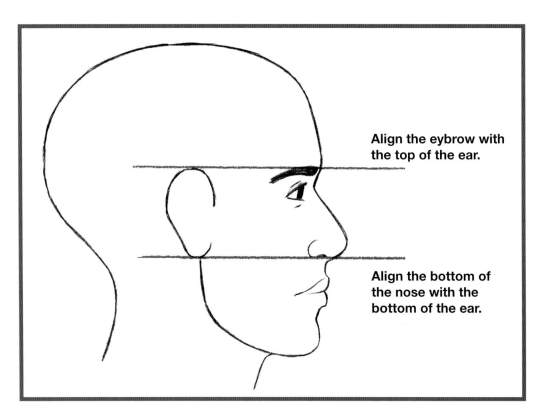

Align the eybrow with the top of the ear.

Align the bottom of the nose with the bottom of the ear.

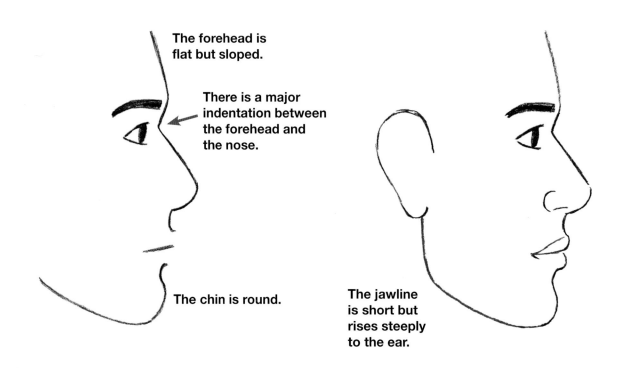

The forehead is flat but sloped.

There is a major indentation between the forehead and the nose.

The chin is round.

The jawline is short but rises steeply to the ear.

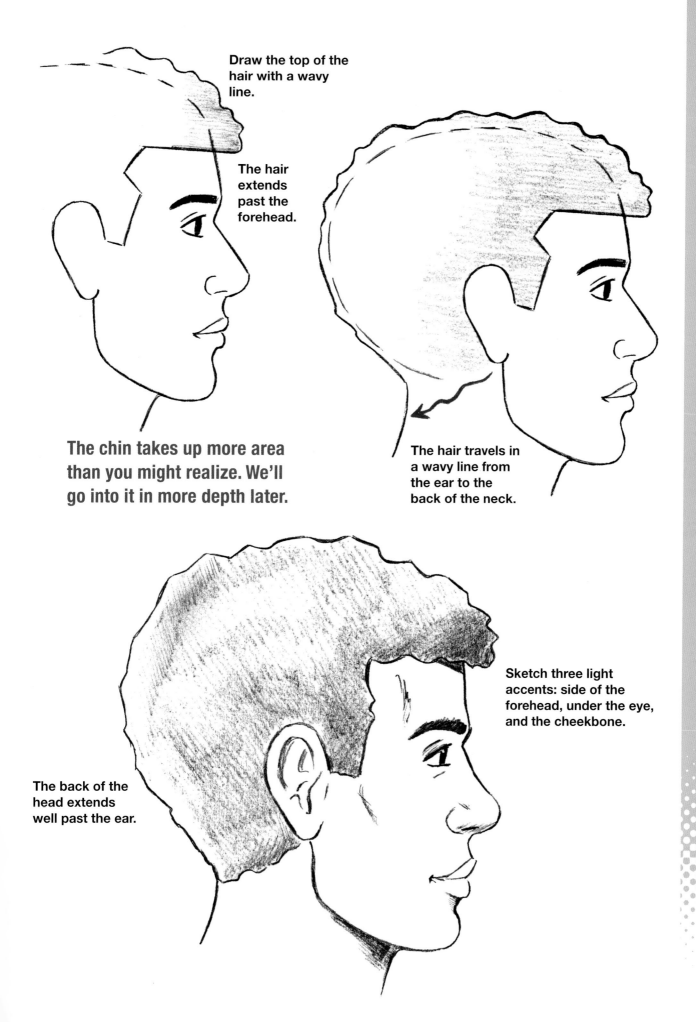

Draw the top of the hair with a wavy line.

The hair extends past the forehead.

The chin takes up more area than you might realize. We'll go into it in more depth later.

The hair travels in a wavy line from the ear to the back of the neck.

The back of the head extends well past the ear.

Sketch three light accents: side of the forehead, under the eye, and the cheekbone.

Directionality

Pencil lines are dynamic. They want to go somewhere. We can use this principle to add direction to the features, which will unify the look of the face.

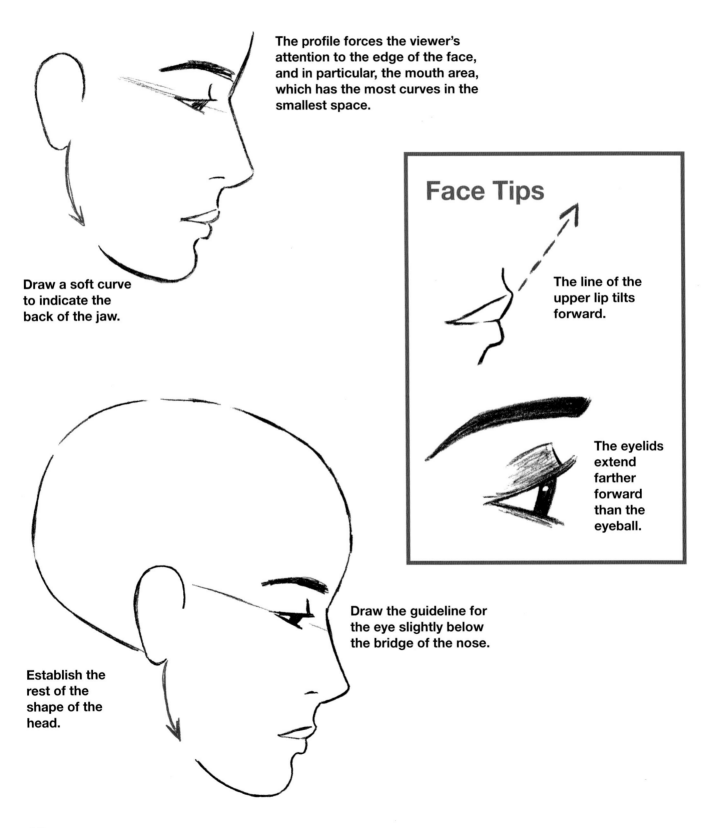

The profile forces the viewer's attention to the edge of the face, and in particular, the mouth area, which has the most curves in the smallest space.

Draw a soft curve to indicate the back of the jaw.

Face Tips

The line of the upper lip tilts forward.

The eyelids extend farther forward than the eyeball.

Draw the guideline for the eye slightly below the bridge of the nose.

Establish the rest of the shape of the head.

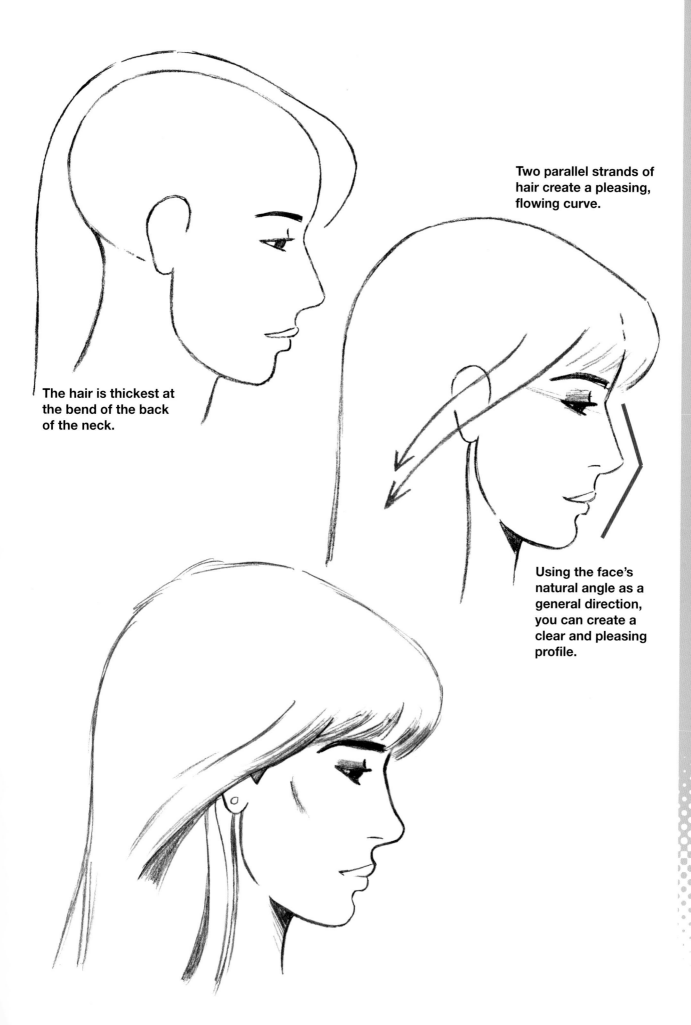

Two parallel strands of hair create a pleasing, flowing curve.

The hair is thickest at the bend of the back of the neck.

Using the face's natural angle as a general direction, you can create a clear and pleasing profile.

Enhance Your Drawing

As we construct a solid side view, we'll look at how to enhance the drawing by adding a few simple touches. These can give your artwork a professional look without a lot of effort. You don't need to use them all at once. Try out one or two, and if you like them, add them to your growing collection of techniques.

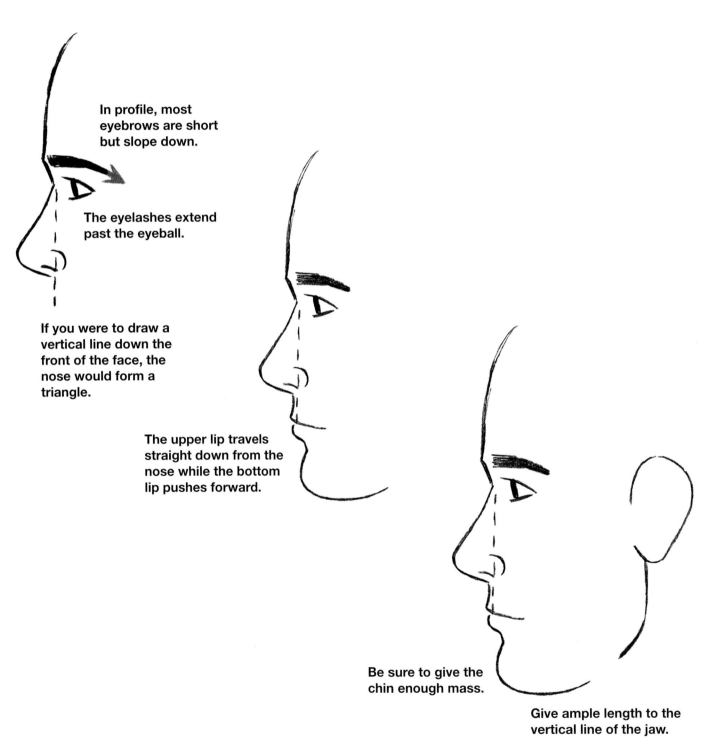

In profile, most eyebrows are short but slope down.

The eyelashes extend past the eyeball.

If you were to draw a vertical line down the front of the face, the nose would form a triangle.

The upper lip travels straight down from the nose while the bottom lip pushes forward.

Be sure to give the chin enough mass.

Give ample length to the vertical line of the jaw.

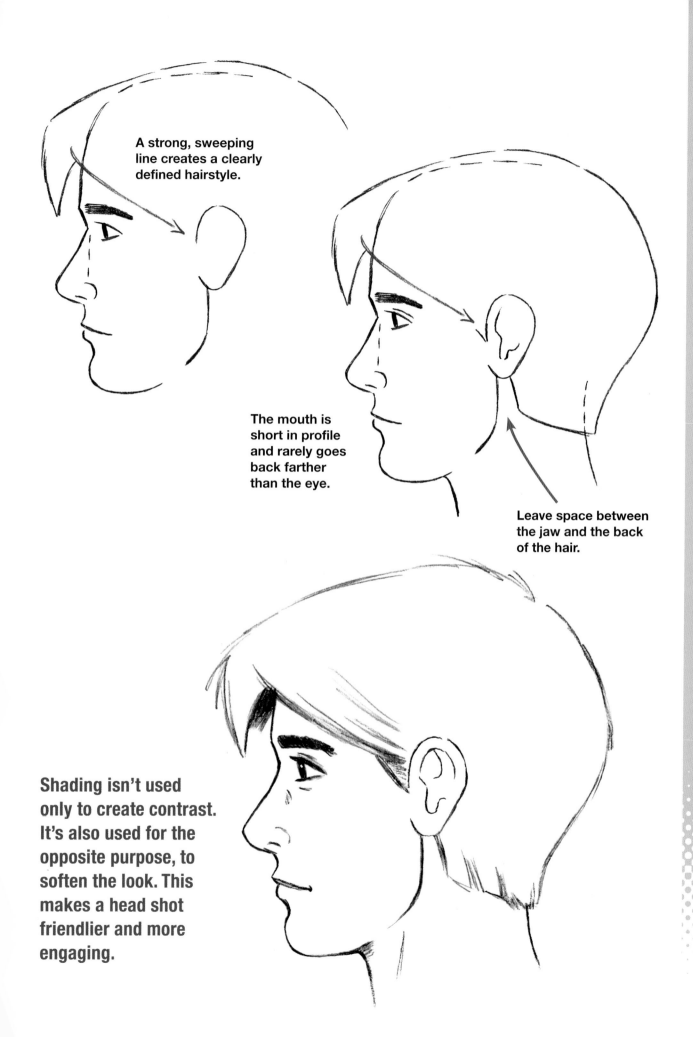

A strong, sweeping line creates a clearly defined hairstyle.

The mouth is short in profile and rarely goes back farther than the eye.

Leave space between the jaw and the back of the hair.

Shading isn't used only to create contrast. It's also used for the opposite purpose, to soften the look. This makes a head shot friendlier and more engaging.

Finishing Touches

It's fun to add finishing touches to a drawing. But here's the irony: If the drawing doesn't have a solid foundation, finishing touches may not improve it. On the other hand, a solid foundation may not need any finishing touches. That's how important a solid foundation is.

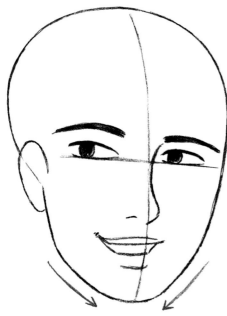

Instead of maintaining a completely round head shape, angle the jaw toward the chin. It's a small adjustment, but it should create a sleeker look in the final step.

Notice that you don't need to do a lot with the eyebrows to create a cheerful expression. Just curve them slightly.

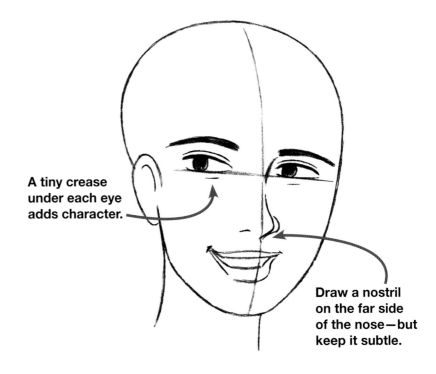

A tiny crease under each eye adds character.

Draw a nostril on the far side of the nose—but keep it subtle.

The 3/4-Angle Smile

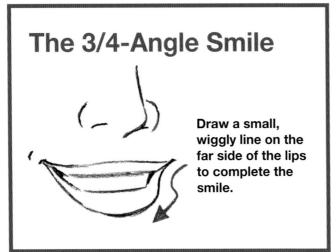

Draw a small, wiggly line on the far side of the lips to complete the smile.

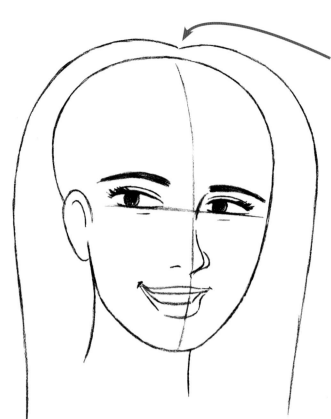

The hair rises up on either side of the part, then flows down on either side of the face.

I like to think of the part as an airport runway. It creates a sense of momentum as the paths diverge.

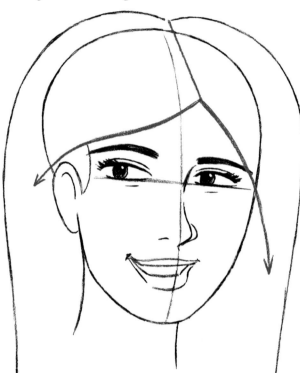

The hair travels around and behind the ear.

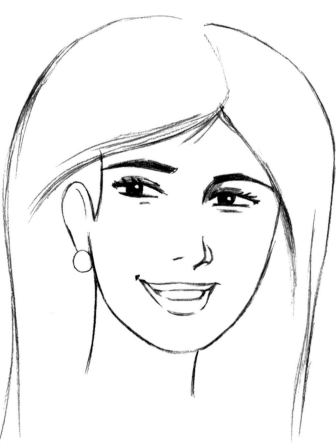

Shade the eyelids and add a few light streaks for the hair.

Erase the bridge of the nose for a light touch.

To add a lustrous look, omit some of the line of the bottom lip.

Turning the Head

When we turn the head, the shape changes. It's easier if we begin with an outline that doesn't have contours. It's just kind of plain. Then draw guidelines to show the direction of the head. The placement of the features clarifies the direction, and small adjustments to the edge of the face tell the viewer exactly what is going on.

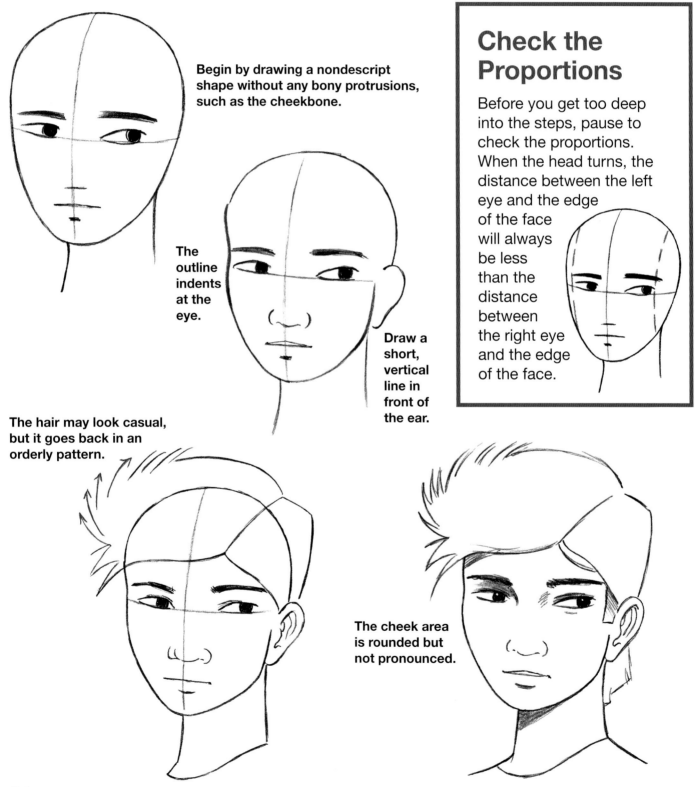

Begin by drawing a nondescript shape without any bony protrusions, such as the cheekbone.

The outline indents at the eye.

Draw a short, vertical line in front of the ear.

Check the Proportions

Before you get too deep into the steps, pause to check the proportions. When the head turns, the distance between the left eye and the edge of the face will always be less than the distance between the right eye and the edge of the face.

The hair may look casual, but it goes back in an orderly pattern.

The cheek area is rounded but not pronounced.

A Fun Project

Let's finish up this chapter on constructing the head with a project that utilizes many of the techniques we've covered so far. Professional artists often need to draw the same character at different angles. This makes a good exercise for working on the fundamentals. Take a drawing—mine or yours—and sketch it in a front view. Next, maintaining the same proportions and guidelines, draw the same head in a side view. Instead of focusing on the features, concentrate on the overall structure of the head.

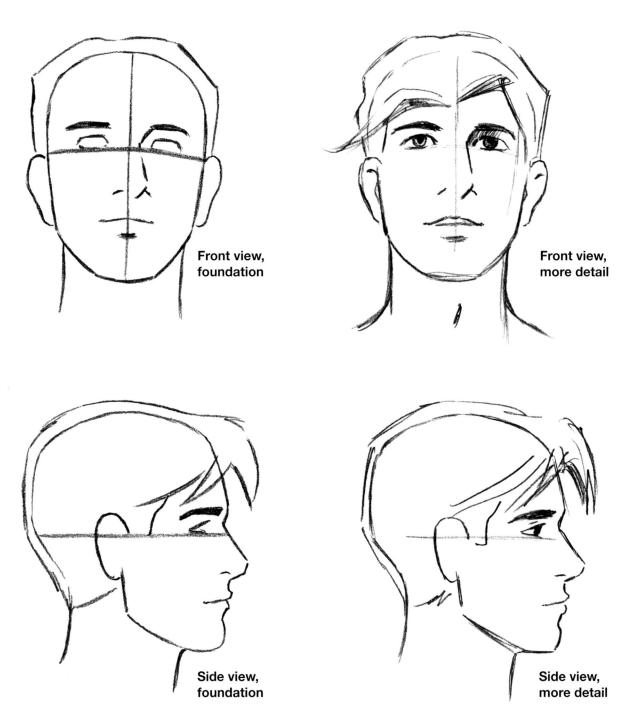

Front view, foundation

Front view, more detail

Side view, foundation

Side view, more detail

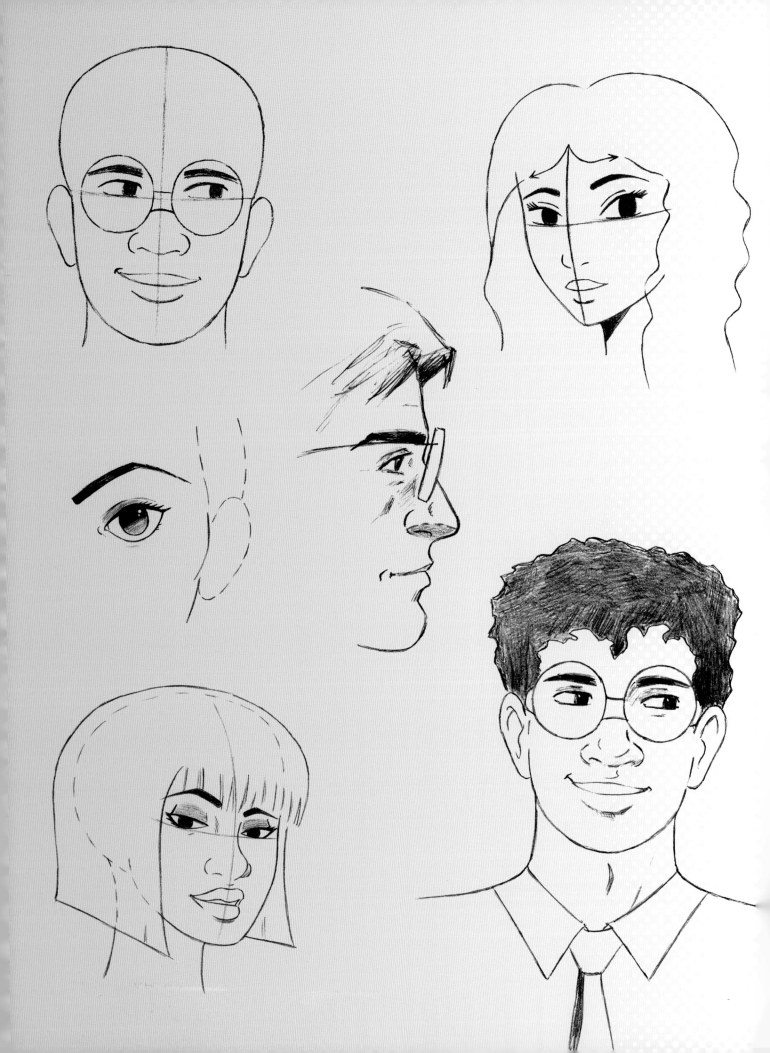

Focus on the Features

So far, we've been looking at the placement of the features as they relate to the proportions of the head. Now, we'll look more closely at the features themselves, to make them appear natural and appealing and to create individual characters. Because the features are small, little modifications can make a big difference. The eyes are the most important feature as they contribute the most to expressions and personalities. And the nose can vary greatly from person to person. We'll focus on the eyes and nose in this chapter.

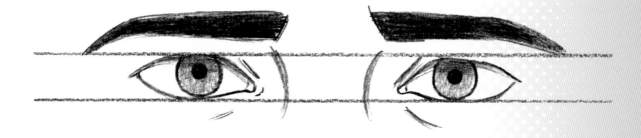

The Eyes

Rather than practicing drawing a single eye, let's draw both so that they work as a unit. You don't want to create detailed eyes only to find out that you need to erase one because it's too low, or because it's looking in a slightly different direction. If you make a mistake like this, don't worry. Everyone has! But we want to avoid it if we can. Ready to try it out?

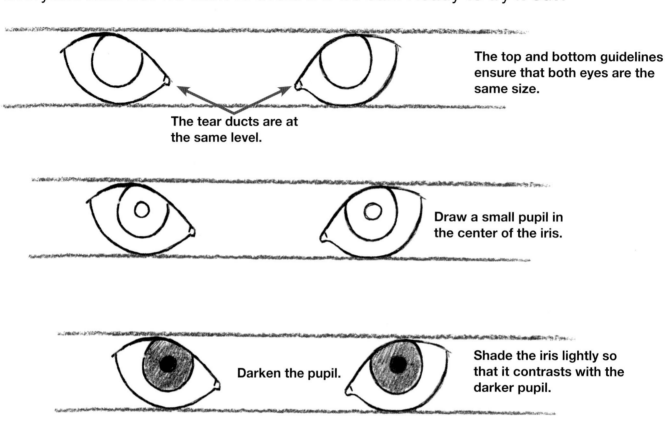

The top and bottom guidelines ensure that both eyes are the same size.

The tear ducts are at the same level.

Draw a small pupil in the center of the iris.

Darken the pupil.

Shade the iris lightly so that it contrasts with the darker pupil.

Draw a subtle line to suggest the upper eyelids.

Draw a few small eyelashes on the outsides of the eyeballs.

The eyebrows are drawn slightly past the outside of the eyes.

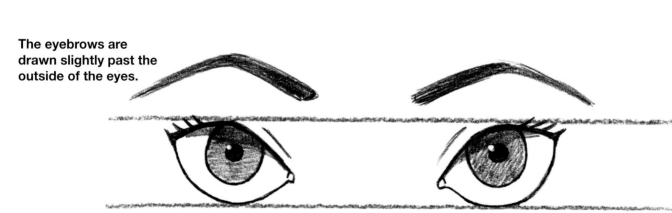

28

Eye Treatments

In addition to the overall shape of the eye, the way you shade the iris and pupil creates a different response in the viewer. Some approaches appear dramatic, some are stark, and others are soft. Here are a few options.

Glowing

The iris has a soft glow with a square of reflected light.

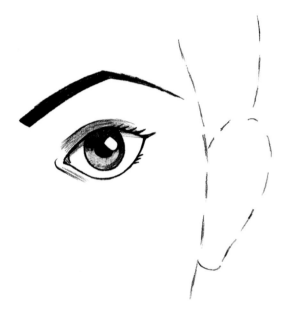

Halftone

The upper half of the eye is black, but the bottom half is halftone. You might think this approach would look stark, but it looks smooth.

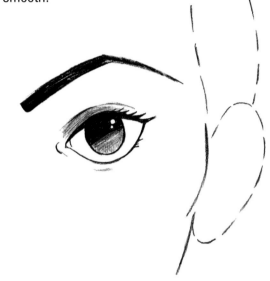

Mottled

The lightly shaded iris is speckled with flecks of light.

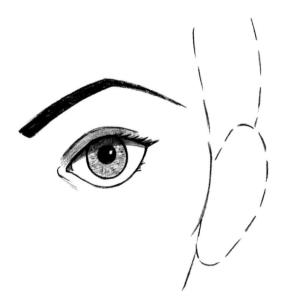

Stark Contrast

This black-and-white approach creates high impact.

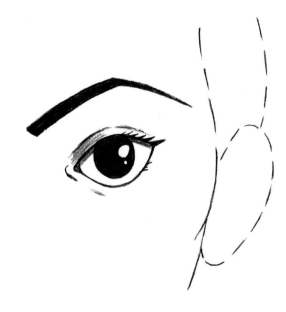

Expressive Eyelids

Eyelids are underused in creating expressions, but they're very effective. Eyelids clearly communicate glances and attitudes. In this example, the eyelids appear heavy and cover much of the eye. But they contribute most of the emotion.

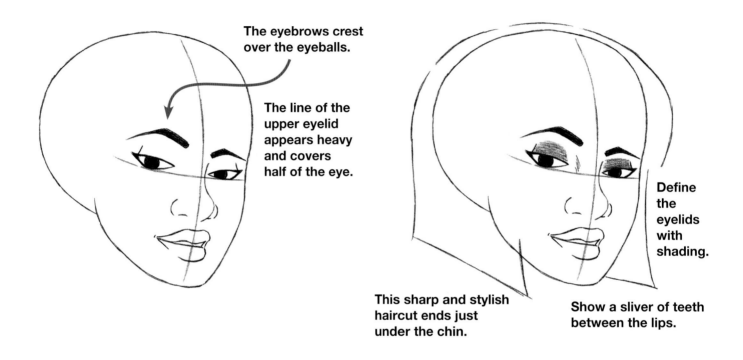

The eyebrows crest over the eyeballs.

The line of the upper eyelid appears heavy and covers half of the eye.

Define the eyelids with shading.

This sharp and stylish haircut ends just under the chin.

Show a sliver of teeth between the lips.

The eyebrows and mouth work in supporting roles.

The upper eyelid is flat, and the lower eyelid sinks.

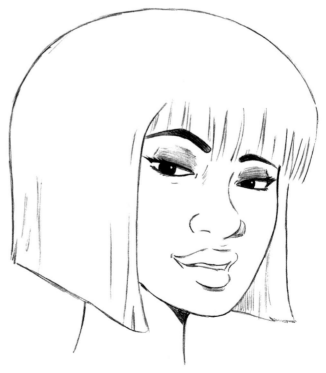

Draw choppy lines across the forehead.

Dramatic Eyes

Brilliant eyes, often a fixture of fashion models, require a slightly different approach. The shape and shading are more severe, which gives the eyes a splashy quality. This approach is a little different, which prompts us to stretch. And stretching is a good thing for artists! Let's give it a try.

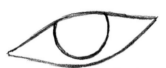

Begin with an elongated eye that swells in the middle.

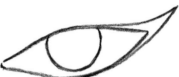

Draw a long, single shaft off the corner of the eye, rather than individual lashes.

Darken the lash area and the outer eyelids.

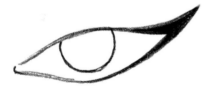

Draw the upper eyelid so that it follows the shape of the eyeball.

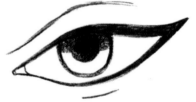

Indicate a small lower eyelid.

Draw a rising eyebrow that tapers off.

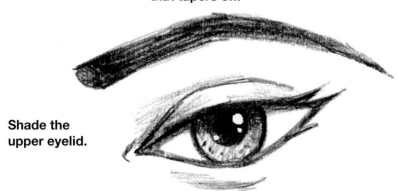

Shade the upper eyelid.

For a natural look, give the eyebrow a slightly random quality with a line that isn't perfectly tidy.

Focus on the Eyes

Now let's take the techniques we just covered for drawing the eyes and apply them, step by step, to drawing the entire face. Rely on the guidelines to create an even look to the eyes. If something looks a little off-center, make a few changes. Bring it back under control. You never have to live with a drawing that you don't like.

Start with a simple foundation shape for the head.

Draw folds for the upper eyelids.

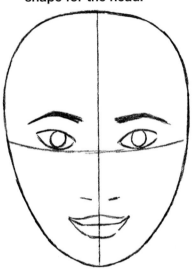

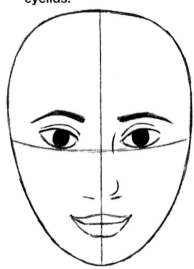

Draw the eyes of equal size and shape.

Darken the eyes to instantly give the image more weight.

Check the Edges

Sometimes, no matter how much you align the eyes, they still don't look right. What happened? The outer edge of one eye may be higher than the outer edge of the other. Check them with this blue line and make a small adjustment.

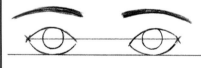

Surround the outer edges of the eyes with thick, black eyelashes.

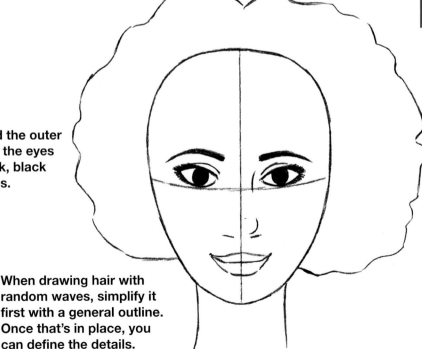

When drawing hair with random waves, simplify it first with a general outline. Once that's in place, you can define the details.

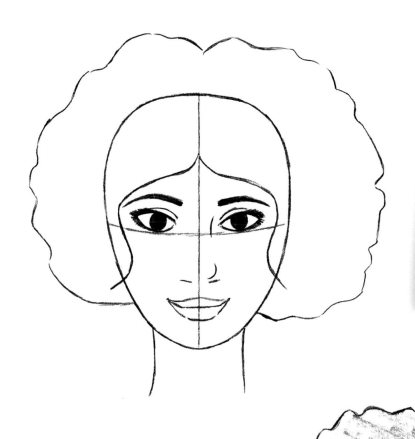

FACE FACTS

Be strategic! When drawing hair in front of the face, create a path so that it opens up around the eyes and overlaps the face below them. It's best to give the eyes room to breathe.

Building up the thickness of the eyelashes can add to the aesthetics of the eyes as much as the shape itself.

FACE FACTS

The upper eyelids are almost always more prominent than the lower eyelids.

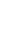

Eyes from Another Angle

Now we're going to add a slight twist. We'll change the angle of the head so it's no longer in a front view. Surprisingly, it's often easier to draw the eyes at an angle than straight ahead. That's because a front view calls for perfect symmetry whereas the three-quarter view does not. Therefore, the three-quarter view is slightly more forgiving.

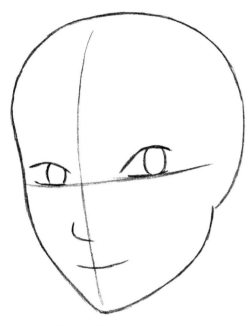

Lay down the overall shape of the head and the bare essentials of the features.

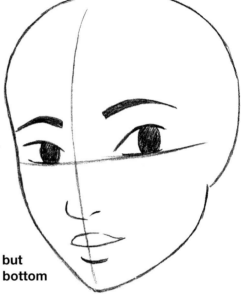

The eye appears slightly compressed on the left side. This helps create an effective three-quarter angle.

Close the upper lip, but leave the line of the bottom lip open.

FACE FACTS

Small details can make a big difference. For variety, the degree of curvature of the upper and lower eyelids is often different.

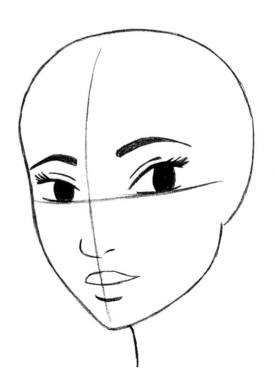

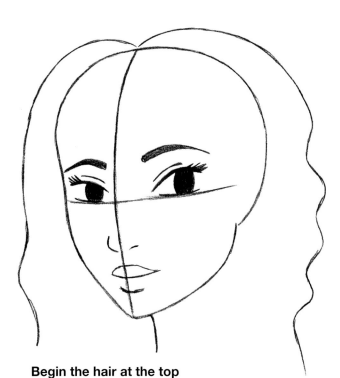

Begin the hair at the top
of the head.

Draw waves of hair overlapping the face.
The hair on the other side of the head is
less wavy and acts as a backdrop.

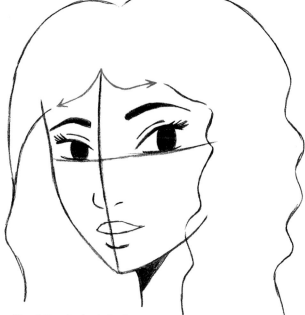

A split of the hairstyle from
the forehead underscores the
centerline.

To create an elegant look, draw
secondary waves that follow the
original ones.

More Eye Tips

Keep these guidelines in
mind when drawing eyes.

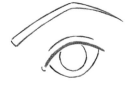

The upper eyelid is longer
than the lower one. It acts
like a canopy for the rest of
the eye.

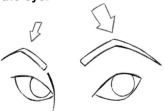

In the three-quarter view,
it can be tricky to align the
eyebrows evenly. An easy
way to adjust for this is to line
up the crest on each one.

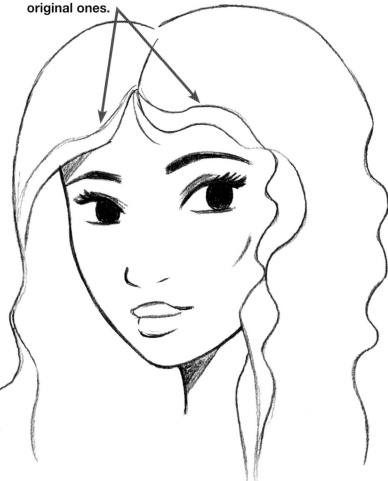

35

Drawing Male Eyes

Male eyes are slightly boxier than female eyes. The eyelids are emphasized less, and the eyelashes are less prominent. But these are not hard-and-fast rules, and men's eye shapes can be adjusted to suit different subjects.

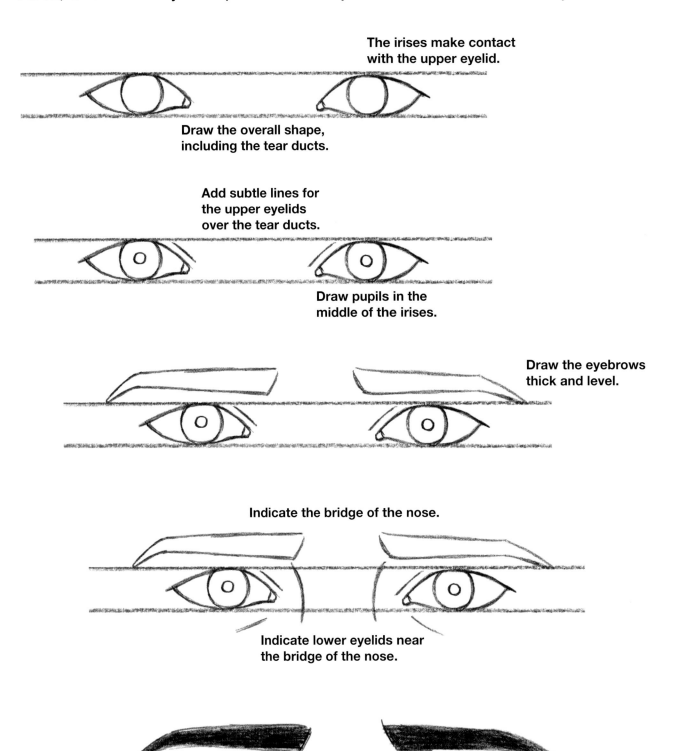

The irises make contact with the upper eyelid.

Draw the overall shape, including the tear ducts.

Add subtle lines for the upper eyelids over the tear ducts.

Draw pupils in the middle of the irises.

Draw the eyebrows thick and level.

Indicate the bridge of the nose.

Indicate lower eyelids near the bridge of the nose.

Create contrast between the pupils and irises.

Male Eyes: Step by Step

Let's draw male eyes in a complete face, one step at a time. The eyebrows and eyes stand out among the other features because they're the darkest areas. And we want that in order to bring focus to the face.

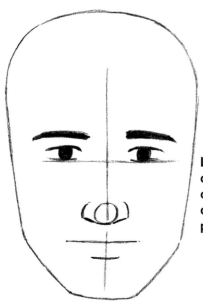

Draw bold eyebrows.

Leave the outside edges of the eyes open for a popular look.

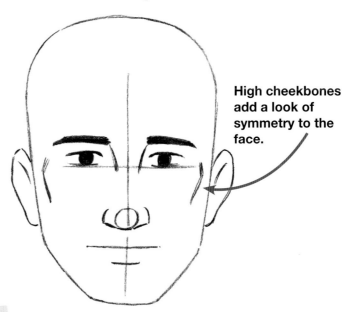

High cheekbones add a look of symmetry to the face.

FACE FACTS

By starting out with the eyes placed evenly along the eyeline, you ensure that the drawing looks right.

The eyes maintain the look of simplicity from the first step—and that's key.

Lightly sketch the hairline and outline of the hair.

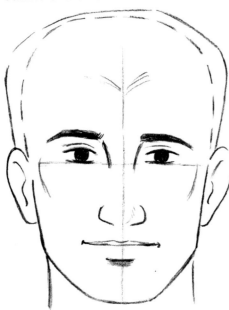

Keep the eyelids light to allow the eyebrows and eyes to stand out.

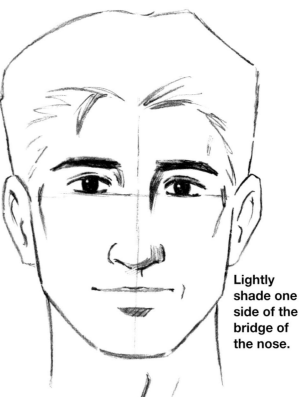

Lightly shade one side of the bridge of the nose.

Drawing Glasses

According to the most recent statistics I've read, almost half the population wears glasses. So it's a good idea to learn to draw them! It's actually sometimes easier to draw faces with glasses because they create a central point of interest. They work best when they allow the viewer to see the eyes clearly.

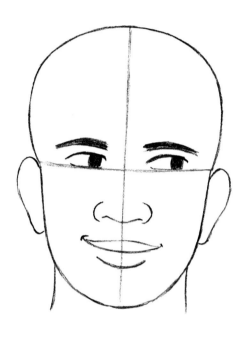

It's also important to align the ears at the same level because glasses draw attention to this area.

Keep It Straight

To keep the ears looking level, draw a guideline across the top and bottom.

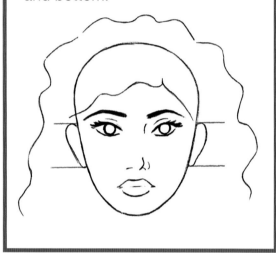

FACE FACTS

Block in the features before drawing the glasses. If you draw the glasses first, and they're slightly tilted, there's the temptation to adjust the eyes to match the position of the lenses.

There is usually less space above the eye and more space below it.

Make the left lens an equal distance from the edge of the face as the right lens.

The bridge of the frames can be any thickness.

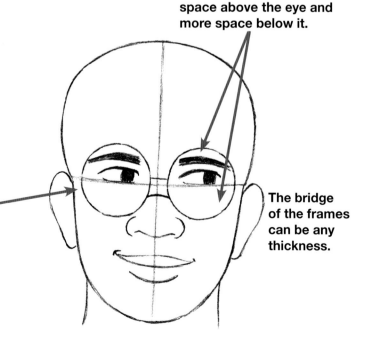

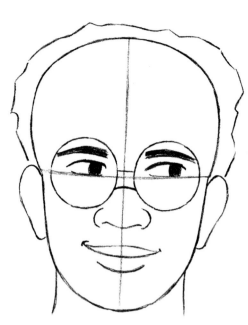

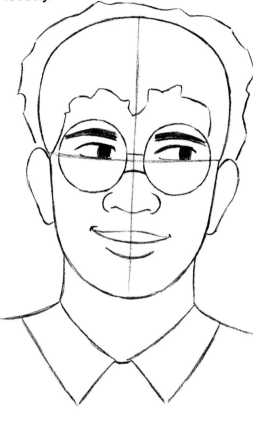

Draw an approximation of the hairline on the forehead, but draw loosely.

The eyebrows are drawn inside the lenses.

Draw small expression lines under the eyes.

Add definition to the nose—lightly.

Different shaped lenses can suggest different personalities. These circular lenses lend a lighthearted look to this affable character.

Side View with Glasses

In profile, glasses sometimes obscure our view of the eye. But we don't want that in our drawings. When you mask the eye, you lose some personality. Our aim will be to keep everything clear.

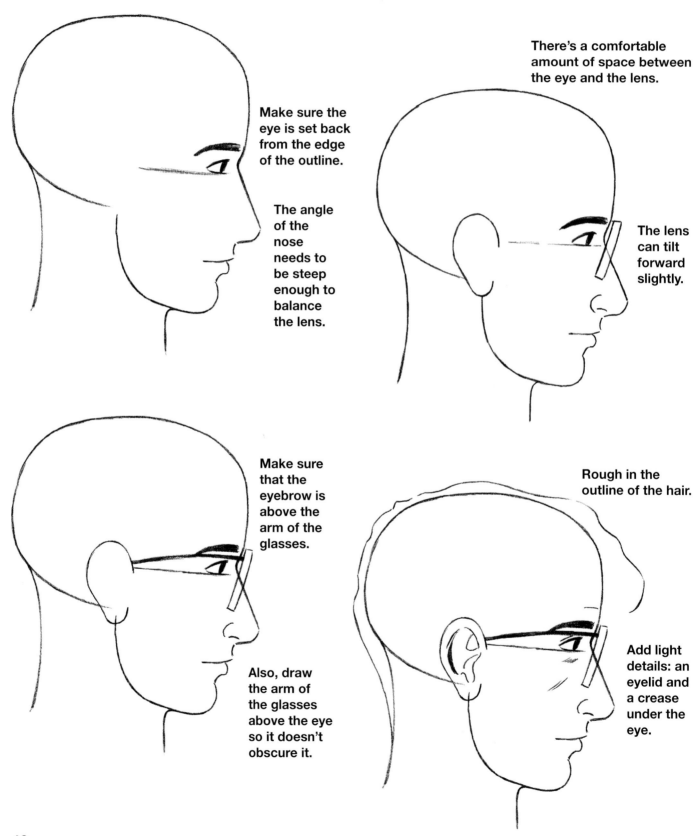

Make sure the eye is set back from the edge of the outline.

The angle of the nose needs to be steep enough to balance the lens.

There's a comfortable amount of space between the eye and the lens.

The lens can tilt forward slightly.

Make sure that the eyebrow is above the arm of the glasses.

Also, draw the arm of the glasses above the eye so it doesn't obscure it.

Rough in the outline of the hair.

Add light details: an eyelid and a crease under the eye.

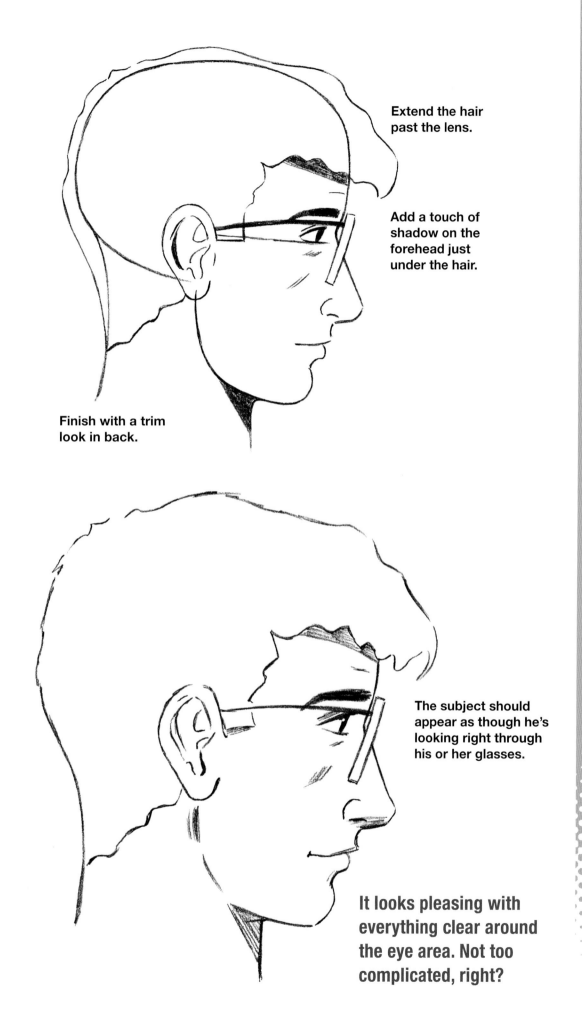

Extend the hair past the lens.

Add a touch of shadow on the forehead just under the hair.

Finish with a trim look in back.

The subject should appear as though he's looking right through his or her glasses.

It looks pleasing with everything clear around the eye area. Not too complicated, right?

With & without Glasses

Glasses make more of an impact than most people realize, and that's an advantage for artists, because we want our drawings to have impact. Let's compare the same face with and without glasses.

THE BASIC TEMPLATE

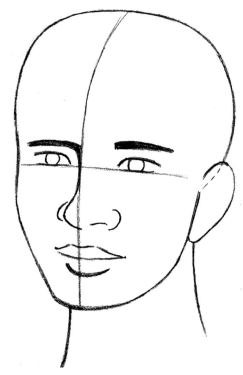

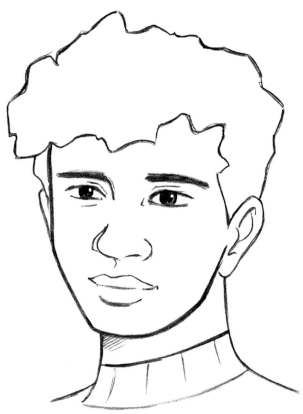

Option 1
This personable-looking young man has an open face. Let's draw him again, keeping the underlying structure and proportions, but with the addition of glasses.

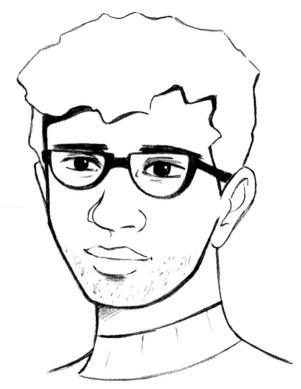

Option 2
He's the same as before, except for the slightly closer haircut and a bit of scruffiness added to his chin. These small changes and the added glasses make him look a little trendier and crystallize his character.

Drawing the Nose

Once you learn how the nose is constructed, drawing it will no longer be a matter of trial and error. We'll start with the bridge of the nose, which creates a strong angle. Even a slight departure from the angle can result in an interesting variation.

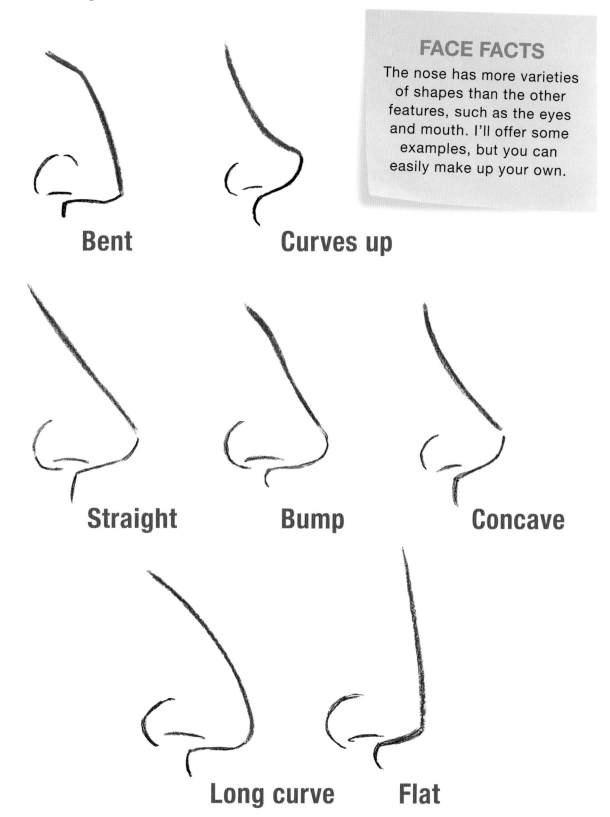

FACE FACTS

The nose has more varieties of shapes than the other features, such as the eyes and mouth. I'll offer some examples, but you can easily make up your own.

Bent

Curves up

Straight

Bump

Concave

Long curve

Flat

Up or Down

Noses come in many shapes, but there are two general positions, up and down. In the down position, the viewer looks at the covers of the nostrils. In the up position, the viewer sees the underside. A little adjustment of the nostrils is all you need to change the look of the nose.

Nose Down

When the tip of the nose is down, you can't see the underside of the nose or nostrils.

Nose Up

In the up position, you can see the underside of the nose and especially the nostrils.

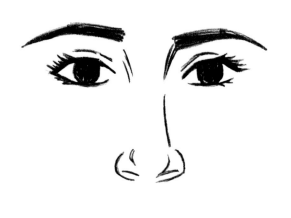

FACE FACTS

Avoid too much detail in the nose. A lighter touch works best.

Noses are constructed differently so that some nostrils will angle up and some will angle down, even when the face is looking straight ahead.

44

Helpful Concepts

Before we move on to drawing more faces step by step, here are a few more tips for drawing the nose that will make it look natural and well constructed.

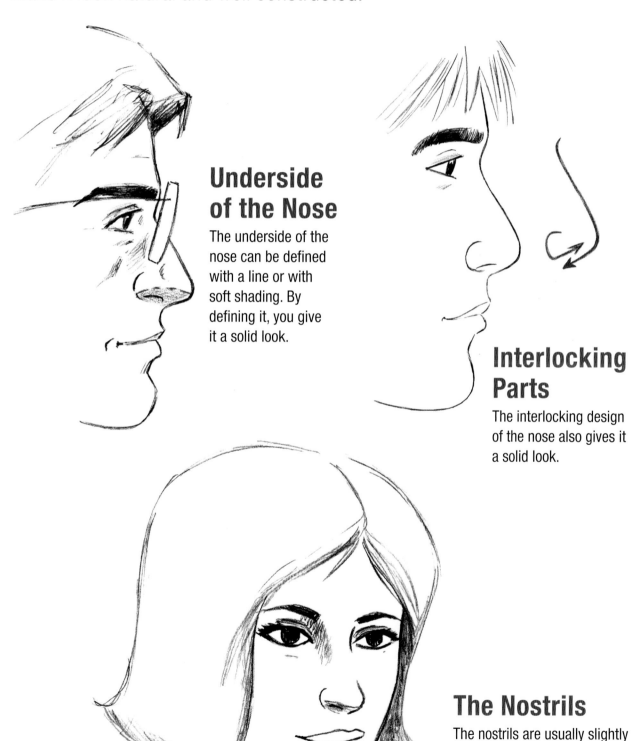

Underside of the Nose

The underside of the nose can be defined with a line or with soft shading. By defining it, you give it a solid look.

Interlocking Parts

The interlocking design of the nose also gives it a solid look.

The Nostrils

The nostrils are usually slightly higher than the tip of the nose.

Front View: Step by Step

The nose is often drawn in a neutral position—neither tilted up nor down—but still showing a bit of the underside. This gives the nose dimension so it doesn't appear completely flat.

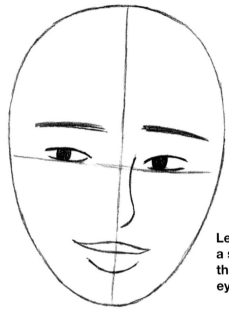

Let's give this face a sly smile. And for that, long and flat eyebrows work well.

The bridge of the nose seems to favor the right side. But because this is a front view, both nostrils need to be evenly placed from the centerline.

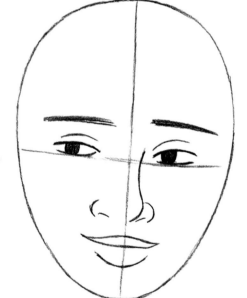

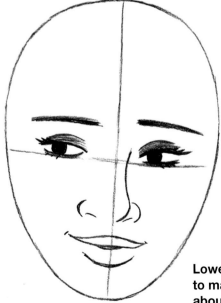

Shade the upper eyelids and add a touch of shading below the eyes.

Draw medium-length eyelashes on top of the eyes and shorter ones on the bottom.

Lower the bottom lip a touch, to make it appear as if she's about to speak.

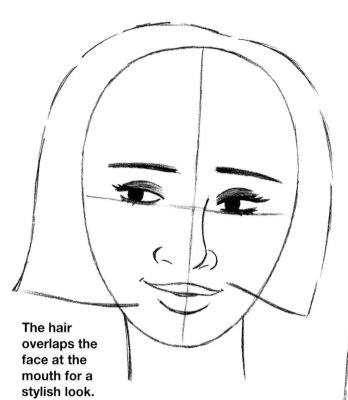

Draw one long line and one short line from the middle part.

The hair overlaps the face at the mouth for a stylish look.

Make sure that the hair overlaps the face to a good degree. Whenever you use the "overlap" technique, use it boldly.

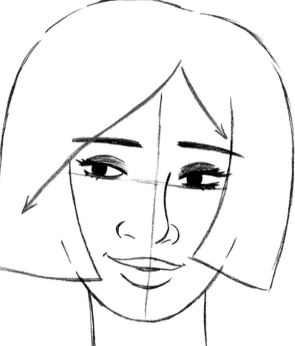

This face has been drawn with a few, simple elements, which are foundational. This demonstrates, once again, that struggling with the details is required!

Lightly shading one side of the nose suggests roundness and provides contrast.

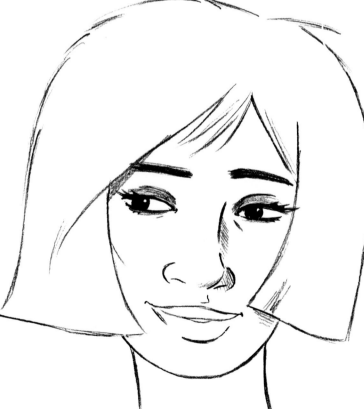

47

Upturned Nose: Step by Step

At most angles, the viewer sees some of the underside of the nose. Therefore, it's good to be familiar with its basic construction. If it sounds complicated, don't worry. This tutorial will show you an easy way to draw the nose at an upturned angle.

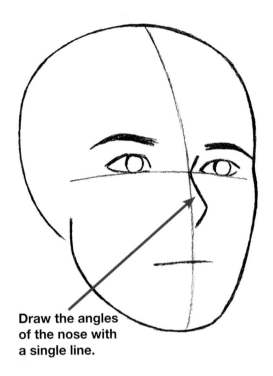

Draw the angles of the nose with a single line.

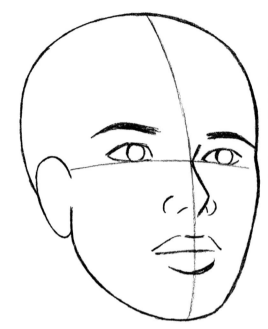

Leave a comfortable amount of space between the eyebrows and the eyes.

The bridge of the nose touches the centerline.

The nostrils are angled toward the tip of the nose.

Zig and Zag

The nose is comprised of three different lines:
- forehead curve (green)
- bridge of nose (red)
- underside of nose (blue)

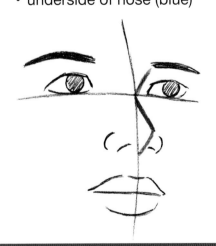

Draw a short line to indicate the near side of the bridge of the nose.

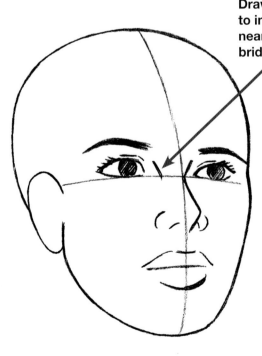

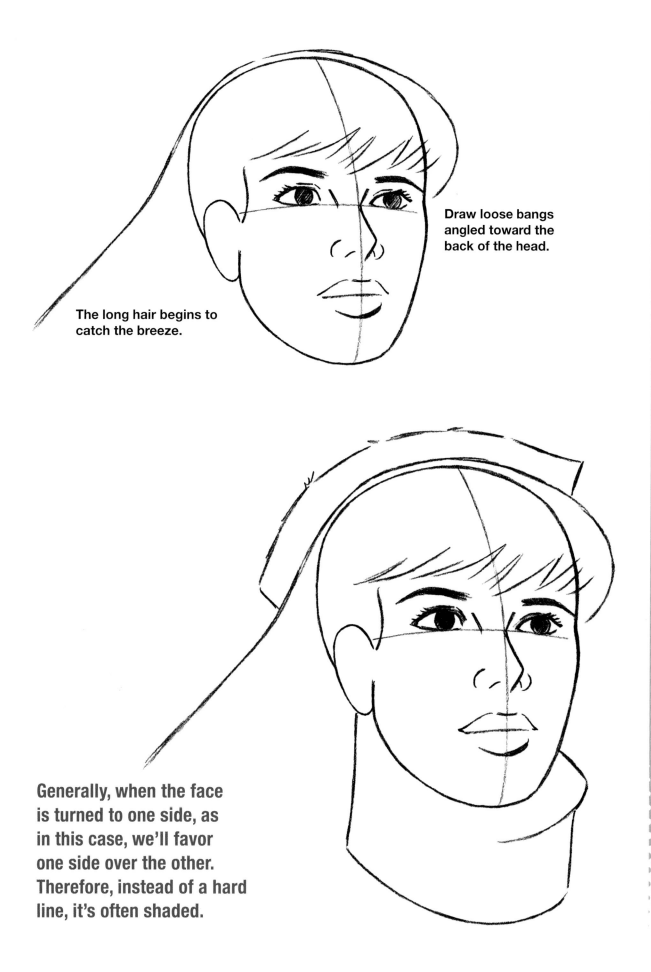

Draw loose bangs angled toward the back of the head.

The long hair begins to catch the breeze.

Generally, when the face is turned to one side, as in this case, we'll favor one side over the other. Therefore, instead of a hard line, it's often shaded.

49

The top of the head overlaps the hat to create dimension.

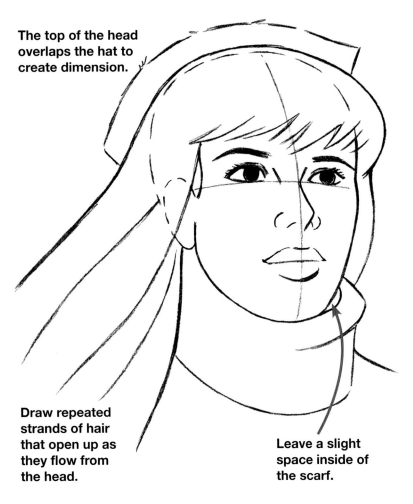

Draw repeated strands of hair that open up as they flow from the head.

Leave a slight space inside of the scarf.

Nose in the Down Position

When the nose is tilted slightly down, you cannot see the holes under the nostril caps. This is a good choice when you want to simplify the drawing.

With the nose simplified, the emphasis switches to the eyes.

A slightly upward angle of the head works well to convey thoughtful expressions.

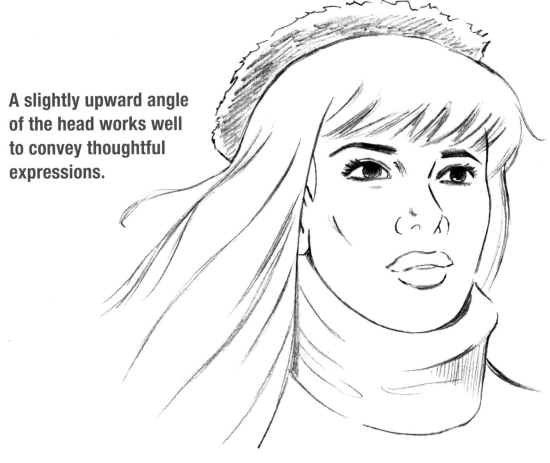

Nose Treatments

There are popular variations for drawing the nose based on how much of the nose artists want to articulate. Sometimes it's a light touch, and other times, it's more literal. Here are three popular versions to try.

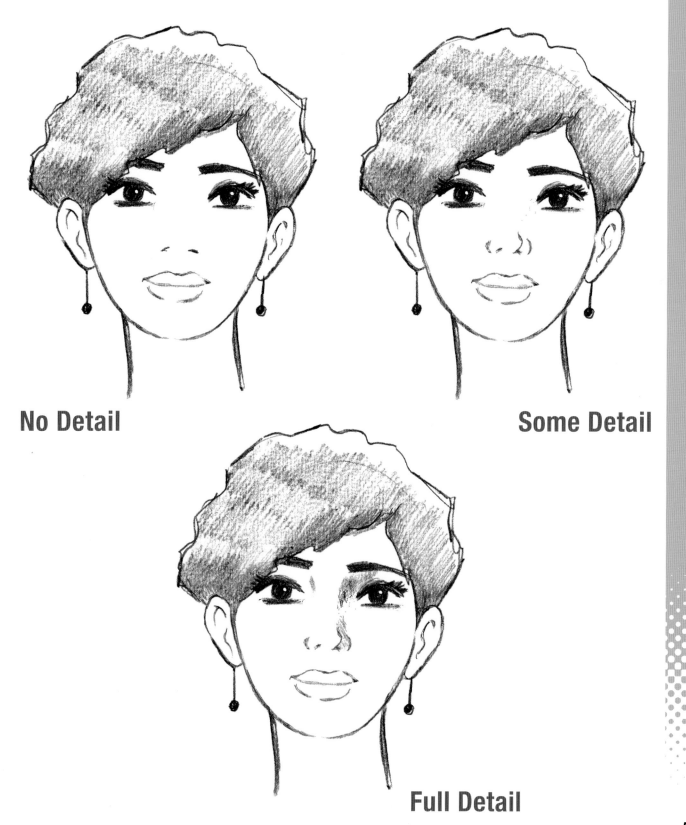

No Detail

Some Detail

Full Detail

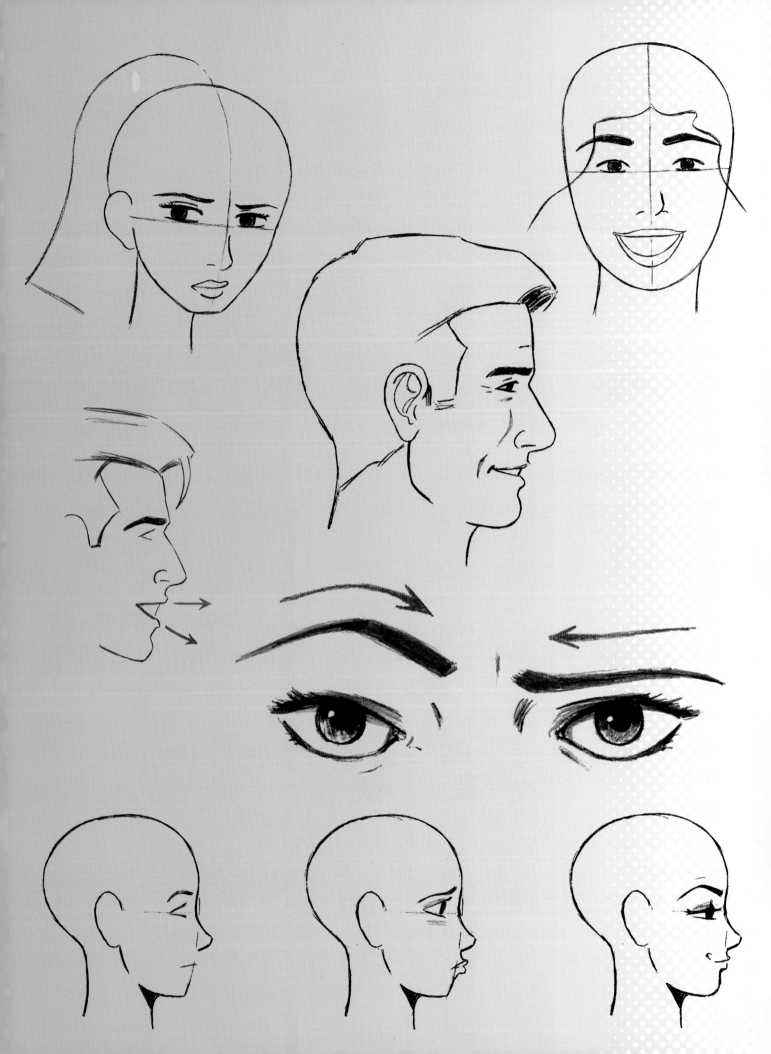

Express Yourself!

We tend to think of expressions as located in only one spot of the face, such as a smile occurring at the mouth, or anger occurring in the eyebrows. But that's not how it works. Expressions are linked together and work as a unit, which includes all of the features . . . even the contours of the face. In this chapter, we're going to see how that works. I hope you'll find these ideas fun, useful, and most of all, helpful in your artwork.

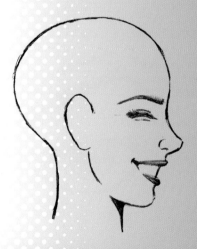

Expressive Eyebrows

In some ways, eyebrows communicate emotions even better than the eye itself. Eyebrows create strong lines that spread apart, converge, lift, and lower. Unlike the eyes, eyebrows don't always remain at the same level, but can move independently of one another, higher or lower, to create different expressions.

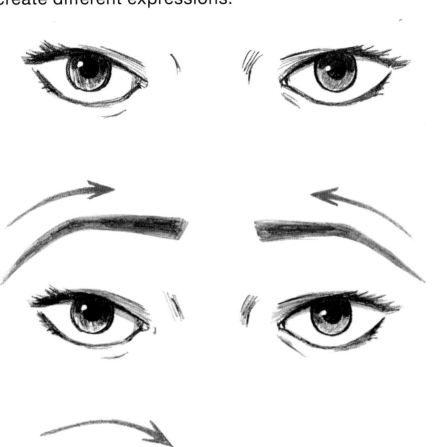

Sample without Eyebrows

Eyes without eyebrows show no expression. On this page, I'll repeat the same eyes, changing only the eyebrows, and you'll quickly notice how big a difference they make.

Calm

An open and honest expression starts with eyebrows drawn with a gradually rising arch and ample space above the eyes.

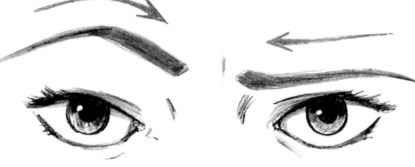

Skeptical

Skeptical eyebrows are drawn on two different levels, one higher than the other.

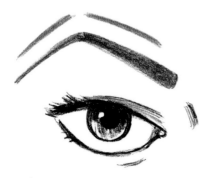
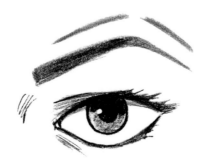

Piercing Look

The eyebrows are drawn with high arches and dip at the bridge of the nose.

The Famous Eyebrow Crease

You'll probably recognize a small, vertical crease that appears between the eyes in certain expressions. It's caused by the direction of the force of the two eyebrows. Different emotions can create this effect, which adds intensity to expressions.

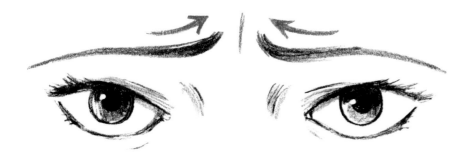

Concern

Concerned eyebrows converge and turn up slightly in the middle.

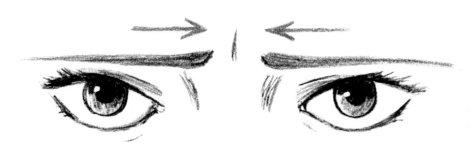

Serious

Completely straight eyebrows command attention because they create the illusion of a single, long line from one side to the other.

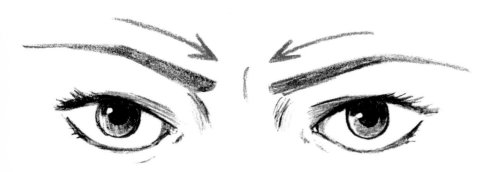

Annoyed

Eyes don't need to be furious to be affective. Just draw eyebrows that take a sudden dip at the center.

Smile Lines

A face can be pleasant, but if it doesn't have any wrinkles or creases, it will lack impact. That's because the force of the smile doesn't appear to have any effect. We have a number of good options we can try in order to enliven the expression.

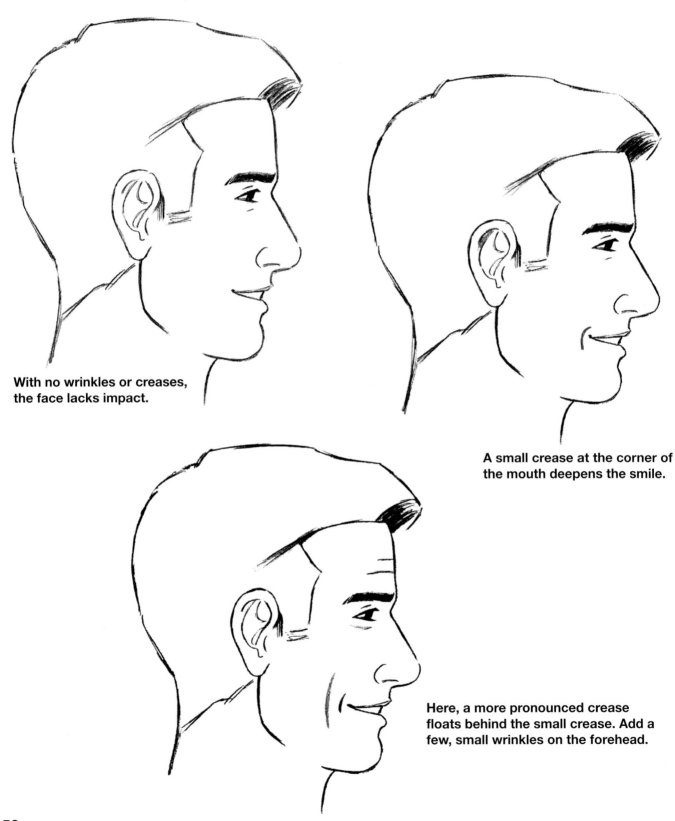

With no wrinkles or creases, the face lacks impact.

A small crease at the corner of the mouth deepens the smile.

Here, a more pronounced crease floats behind the small crease. Add a few, small wrinkles on the forehead.

This crease stretches from behind the nostril to the lips.

When the mouth pulls back, it can cause the cheek to bunch up. This creates a lively expression.

Smile Profile

Drawing a smile in a profile presents a unique challenge. You'll want to make the expression big enough to make an impact. But you can't stretch the lips too far in a side view. So, what do you do? Focus on the shape of the mouth. If the shape is correct, it will look good whether it's large or small.

In profile, the smile is shaped like a wedge of pie.

Simplified Expressions in Profile

The profile compresses the eyebrows, eyes, and mouth. As a result, subtle changes have a bigger effect on the viewer. Begin by copying a simple head and face, then complete the character with your choice of hairstyle, neckline, and expression.

BASIC TEMPLATE

The basic template in profile can be as simple as this. The forehead and the bridge of the nose move very little, but the mouth will be pushed up or down by the expression.

Eager

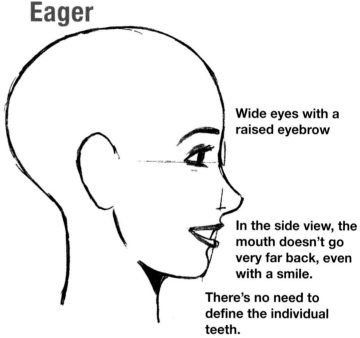

Wide eyes with a raised eyebrow

In the side view, the mouth doesn't go very far back, even with a smile.

There's no need to define the individual teeth.

Glum

A sloping eyebrow flicks up at the forehead.

Draw the eyelid slightly lowered.

The lips push forward.

Judgmental

Raised eyebrow with a sharp angle

The eyelid presses down on the eye, giving it a skeptical quality.

Draw small lips pressed together.

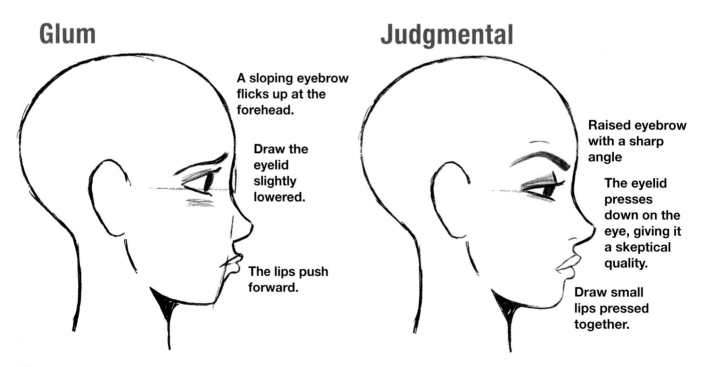

Astonished

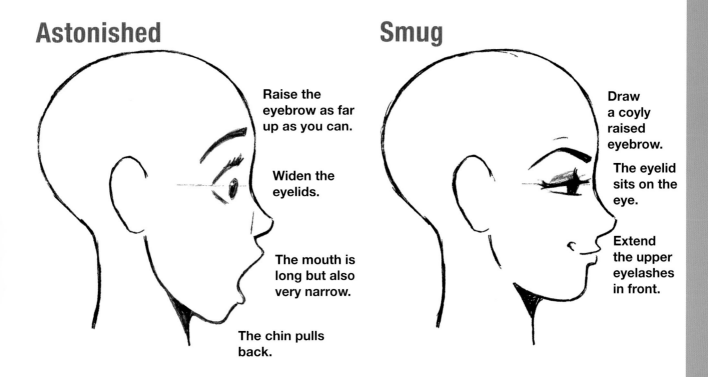

Raise the eyebrow as far up as you can.

Widen the eyelids.

The mouth is long but also very narrow.

The chin pulls back.

Smug

Draw a coyly raised eyebrow.

The eyelid sits on the eye.

Extend the upper eyelashes in front.

Big Smile

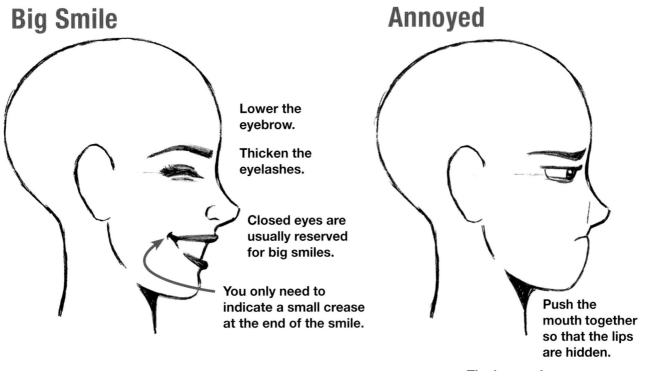

Lower the eyebrow.

Thicken the eyelashes.

Closed eyes are usually reserved for big smiles.

You only need to indicate a small crease at the end of the smile.

Annoyed

Push the mouth together so that the lips are hidden.

The jaw pushes up, so the chin looks longer.

This is one of the few expressions in which the lower eyelid plays a bigger role than the upper eyelid.

Troubled Expression

A troubled expression is effective at getting the viewer's emotional involvement, which is what you want. Several things are going on at once in this drawing. The features show turmoil, but you can't tell what she's thinking. She seems to be looking at something, but we don't know what it is. Leaving things unresolved creates more interest, not less.

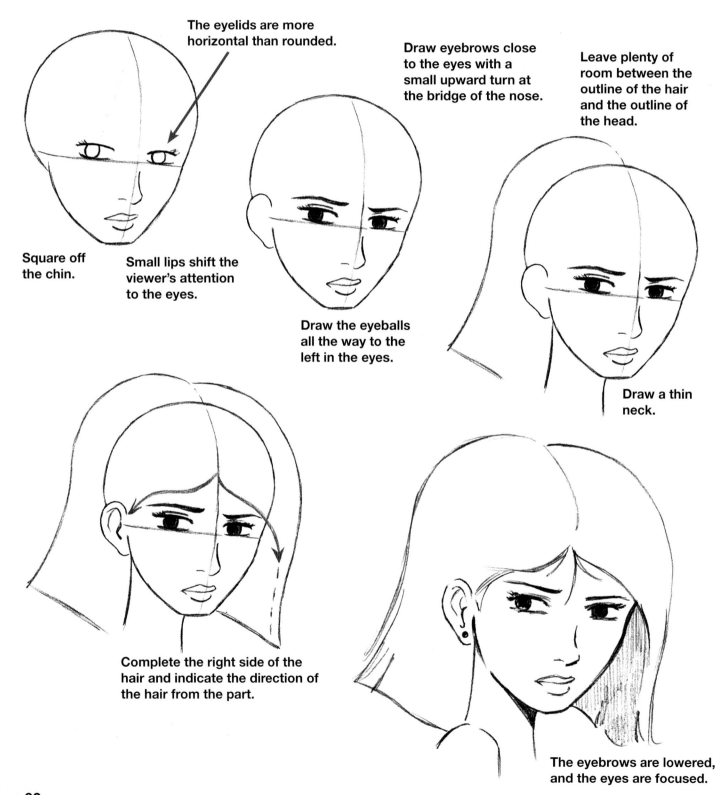

The eyelids are more horizontal than rounded.

Square off the chin.

Small lips shift the viewer's attention to the eyes.

Draw eyebrows close to the eyes with a small upward turn at the bridge of the nose.

Draw the eyeballs all the way to the left in the eyes.

Leave plenty of room between the outline of the hair and the outline of the head.

Draw a thin neck.

Complete the right side of the hair and indicate the direction of the hair from the part.

The eyebrows are lowered, and the eyes are focused.

60

Joyful Expression

When most people think of a cheerful smile, they think of bright eyes. But there's more to it than that. The eyes also have jazzy eyelashes, which are on the small side so as not to overwhelm the expression. Raised eyebrows complete the look.

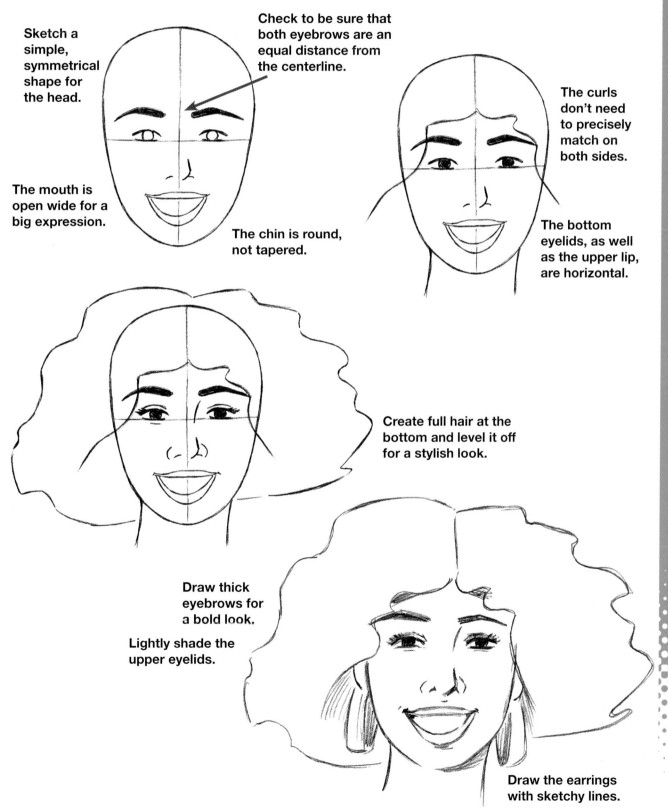

Sketch a simple, symmetrical shape for the head.

Check to be sure that both eyebrows are an equal distance from the centerline.

The mouth is open wide for a big expression.

The chin is round, not tapered.

The curls don't need to precisely match on both sides.

The bottom eyelids, as well as the upper lip, are horizontal.

Create full hair at the bottom and level it off for a stylish look.

Draw thick eyebrows for a bold look.

Lightly shade the upper eyelids.

Draw the earrings with sketchy lines.

Worried Expression

An expression can be a quick response to a specific stimulus. But it can also be the reflection of an internal monologue. In this image, the character shows signs of worry and distress. She looks straight ahead, but her mind is focused inward. Emotions that show some degree of distress can lead the viewer to sympathize with the subject.

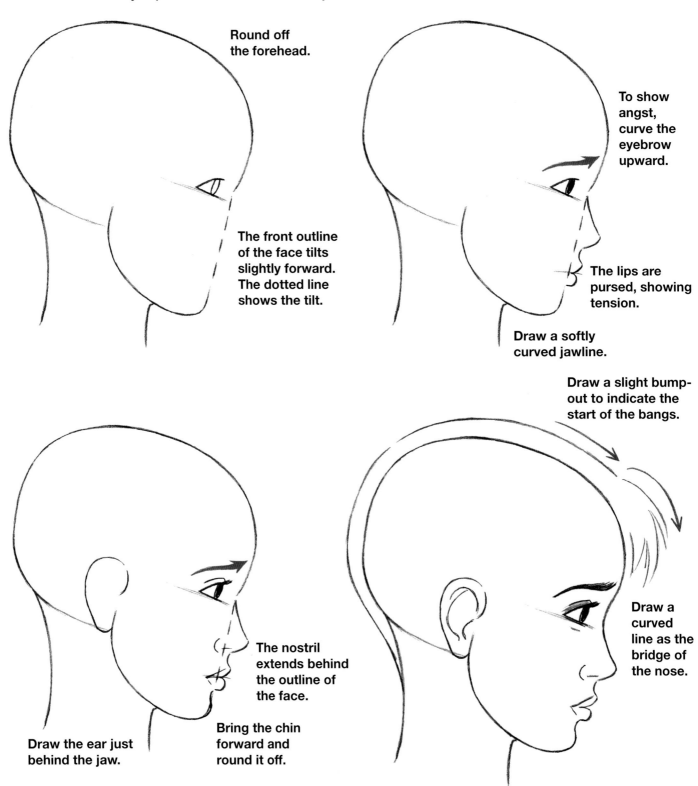

Round off the forehead.

The front outline of the face tilts slightly forward. The dotted line shows the tilt.

To show angst, curve the eyebrow upward.

The lips are pursed, showing tension.

Draw a softly curved jawline.

Draw a slight bump-out to indicate the start of the bangs.

Draw a curved line as the bridge of the nose.

The nostril extends behind the outline of the face.

Draw the ear just behind the jaw.

Bring the chin forward and round it off.

The head is highest in back.

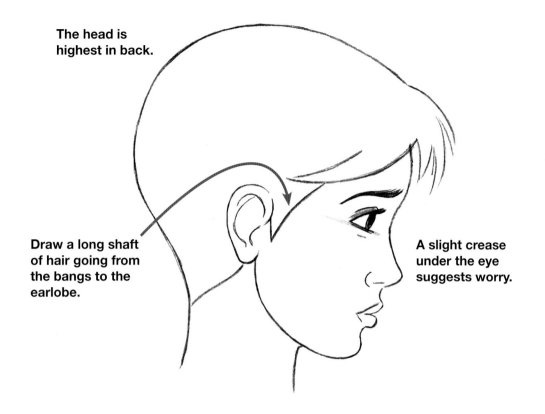

Draw a long shaft of hair going from the bangs to the earlobe.

A slight crease under the eye suggests worry.

Add height at the origin of the ponytail.

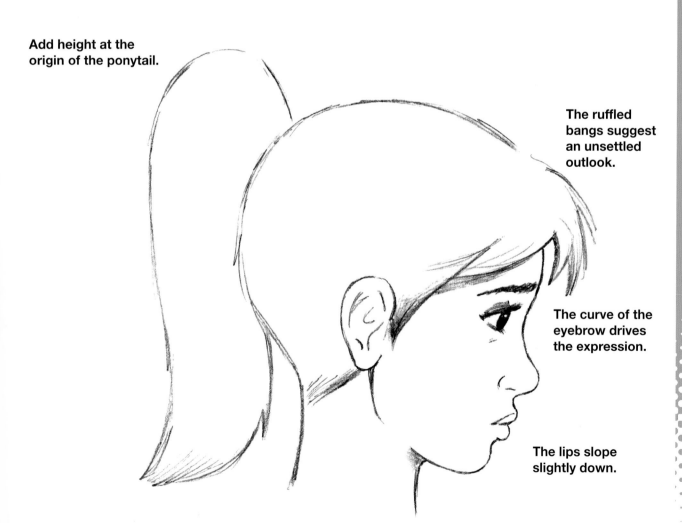

The ruffled bangs suggest an unsettled outlook.

The curve of the eyebrow drives the expression.

The lips slope slightly down.

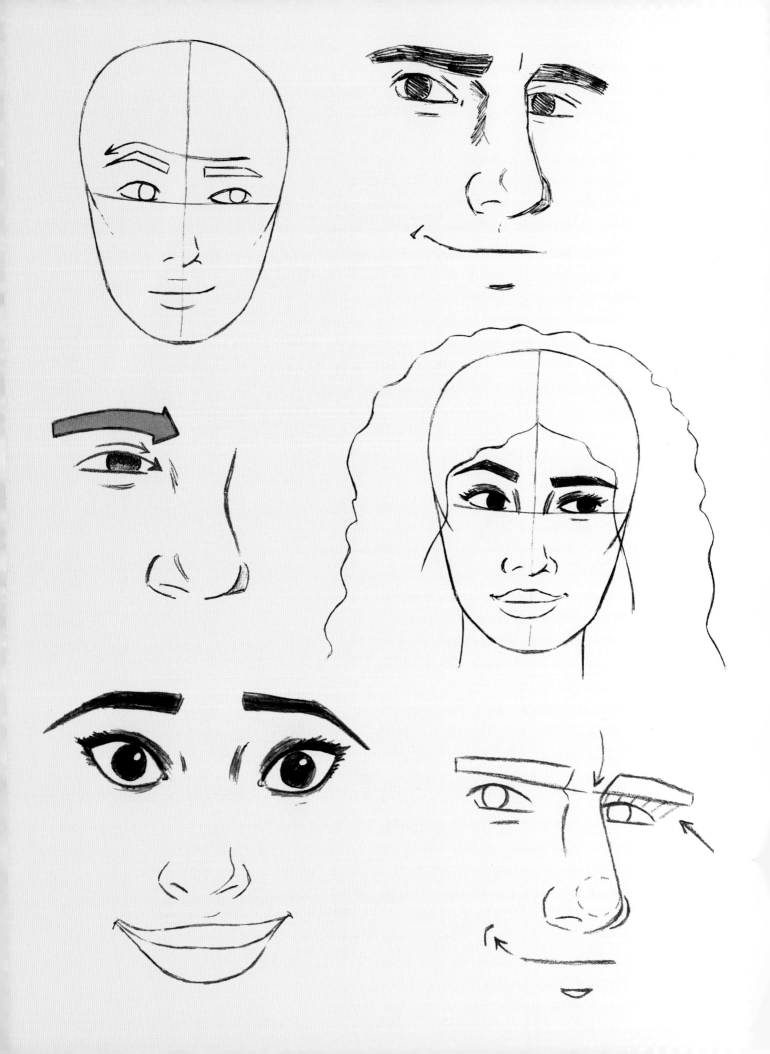

Expressions: Deconstruct Them

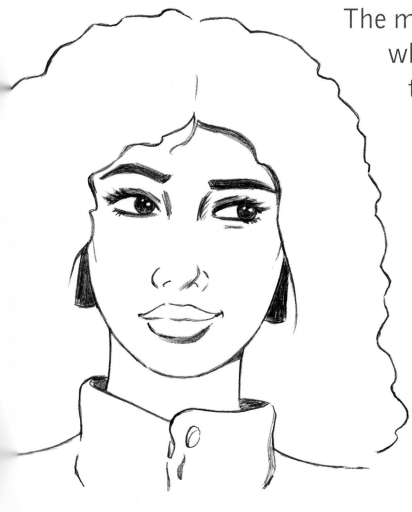

When you deconstruct something, you take it apart to see how it's made. Once you've done that, you can recreate it. You can do the same thing when drawing specific expressions. Expressions are a team effort between the eyebrows, eyes, mouth, and facial creases. The mouth tells the eyes what to do, and the eyes tell the eyebrows what to do. And they do it simultaneously to create expressions the viewer will recognize at a glance. This is the nitty-gritty of expression-making. I think you'll find it interesting and helpful.

Baseline Expression

Before we begin to create and modify expressions, let's look at a face that's relaxed. This is our basic canvas. There's no tension in the face. The features are in their natural positions. To draw expressions, we'll add stressors, which create interest and communicate thoughts and feelings. Our expressions, therefore, will be a variation of this look.

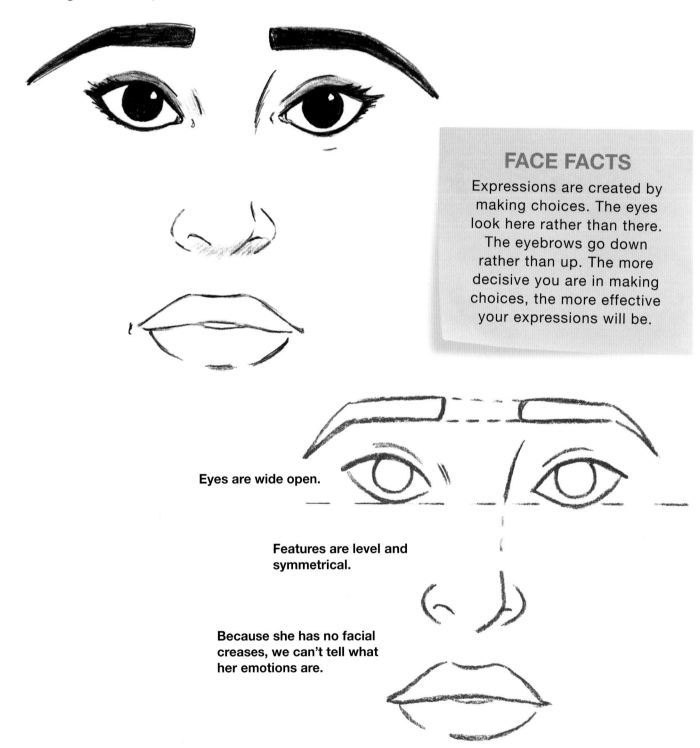

FACE FACTS

Expressions are created by making choices. The eyes look here rather than there. The eyebrows go down rather than up. The more decisive you are in making choices, the more effective your expressions will be.

Eyes are wide open.

Features are level and symmetrical.

Because she has no facial creases, we can't tell what her emotions are.

Skeptical

There's a little bit of the cynic in all of us. This fun expression engages the viewer because it's so relatable. The thing to remember about this expression is that it needs to be underplayed. When a skeptical eye narrows, it narrows only a little.

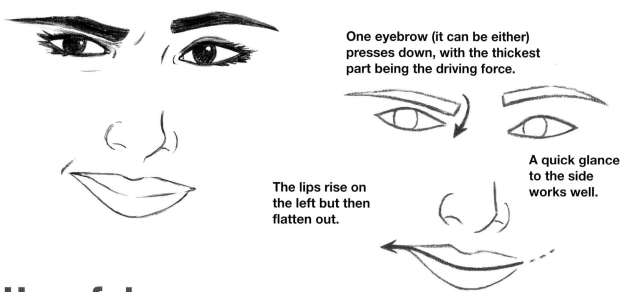

One eyebrow (it can be either) presses down, with the thickest part being the driving force.

A quick glance to the side works well.

The lips rise on the left but then flatten out.

Hopeful

A hopeful expression includes a slight upward line of vision. The person appears to be looking into the distance, but not focused on anything in particular. It's the metaphorical road ahead. The smile is slightly dreamy. The eyes usually point forward.

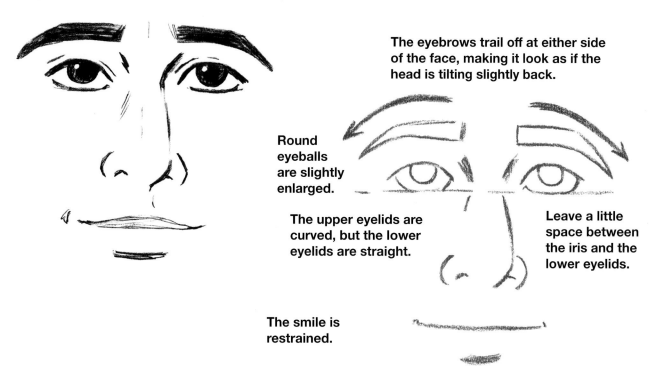

The eyebrows trail off at either side of the face, making it look as if the head is tilting slightly back.

Round eyeballs are slightly enlarged.

The upper eyelids are curved, but the lower eyelids are straight.

Leave a little space between the iris and the lower eyelids.

The smile is restrained.

Concentration

This expression focuses the eyes like a laser beam. Everything on the periphery seems to melt away. I'm not sure if I'd like to be on the receiving end of that glare. The lips appear relaxed; however, it's a dynamic expression with a lot going on. Let's check it out.

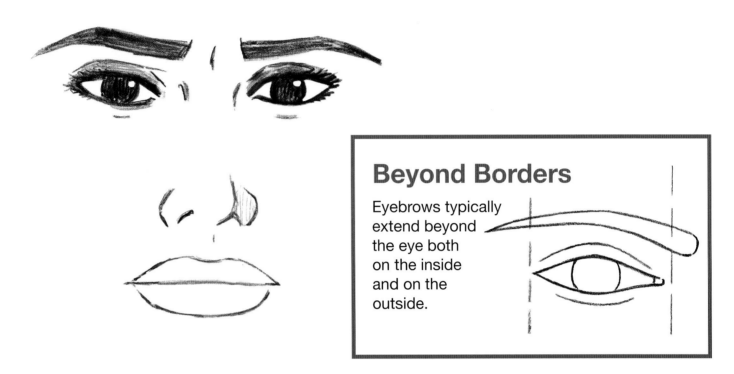

Beyond Borders

Eyebrows typically extend beyond the eye both on the inside and on the outside.

Lower the eyebrows just above the eyes.

The eyebrows are slightly curved and push together.

Notice that the top and bottom of the irises are cut off by the eyelids.

Draw light creases under each eye.

The mouth is horizontal and expressionless, leaving all of the work to the eyes and eyebrows.

Pleased

Most people are aware that creases form at the sides of the lips when a person smiles. Those creases are the result of forces acting upon the face, rather than wrinkles that just appear. Because of that, it's effective to shade them to show depth.

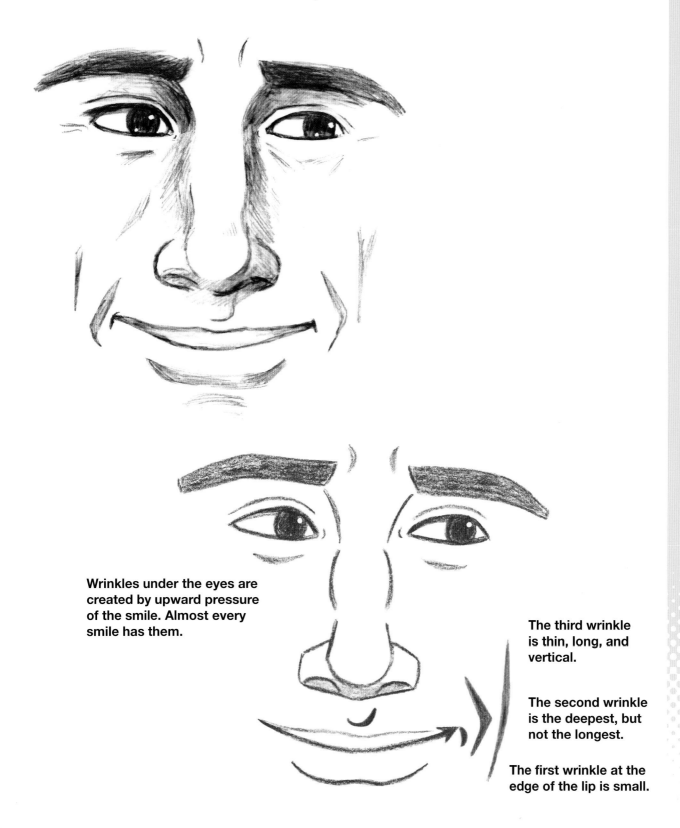

Wrinkles under the eyes are created by upward pressure of the smile. Almost every smile has them.

The third wrinkle is thin, long, and vertical.

The second wrinkle is the deepest, but not the longest.

The first wrinkle at the edge of the lip is small.

The Snarl

The snarl works on the same principle as many other well-known expressions, like sneering, disdain, and contempt. It's based on putting uneven pressure on the eyes by the eyebrows. The flared nostril is important and occurs only on the side where the mouth lifts.

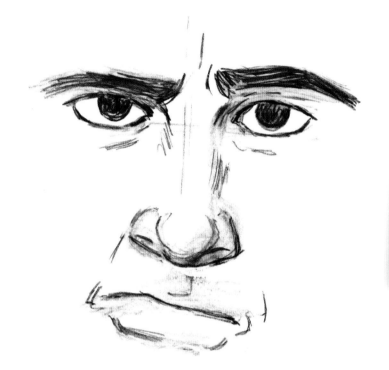

One eyebrow presses down, leaving very little space between the eye and the eyebrow.

The other eye is released from pressure and retains its normal shape.

The nostril rises in response to pressure from the eyebrow.

The mouth rises as a counterbalance to the downward pressure of the eyebrow.

Embarrassed

Blushing is really two expressions melded into one. At the top of the face, we have the eyebrows, which form a sad expression. At the bottom of the face, we have the mouth, which makes an awkward smile. While the eyebrows cut a clear and strong look, the most important aspect of the embarrassed expression is the slight tug at the corner of the mouth on the right side.

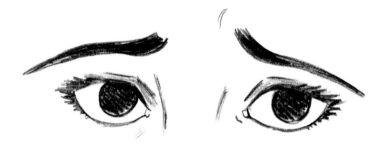

Note the all-important dip in the eyebrows. Even though the shape is uneven, the left eyebrow is almost a mirror image of the one on the right.

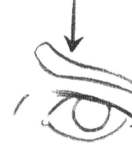

The eyelids slope steeply.

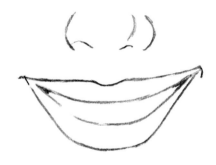

The smile is purposely lopsided, with the lips tugging more to the right. It's a smile . . . but not exactly a happy smile.

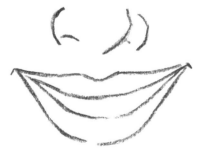

Resentment

Resentment is a common expression, which is best when underplayed. If it's too energized, it becomes anger, which may be an appropriate emotion for a different scene. Anger is abrasive and may push the viewer out of the moment. Restraint is often our first choice.

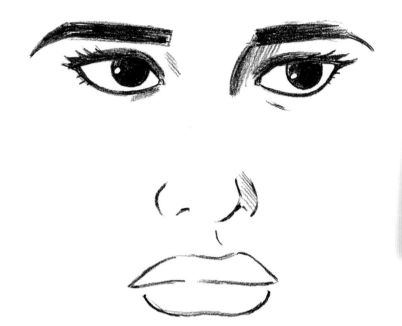

FACE FACTS

Some expressions get their power not from a big display of energy, but from a sense of restraint.

Flat eyebrows push toward each other.

Notice how the tops of the eyelids also flatten.

The irises are partially covered on top by the eyelids, which gives the eyes attitude.

The top lip is flat, but the lower lip is round and full.

Fright

A look of fright doesn't bother the viewer. Instead, it makes the viewer wonder what the character is looking at. Even though the expression is "big," nothing much is happening. The character isn't screaming. Smoke isn't flying off his head. By using a simple, but effective, template, we can create the emotion without wild exaggeration.

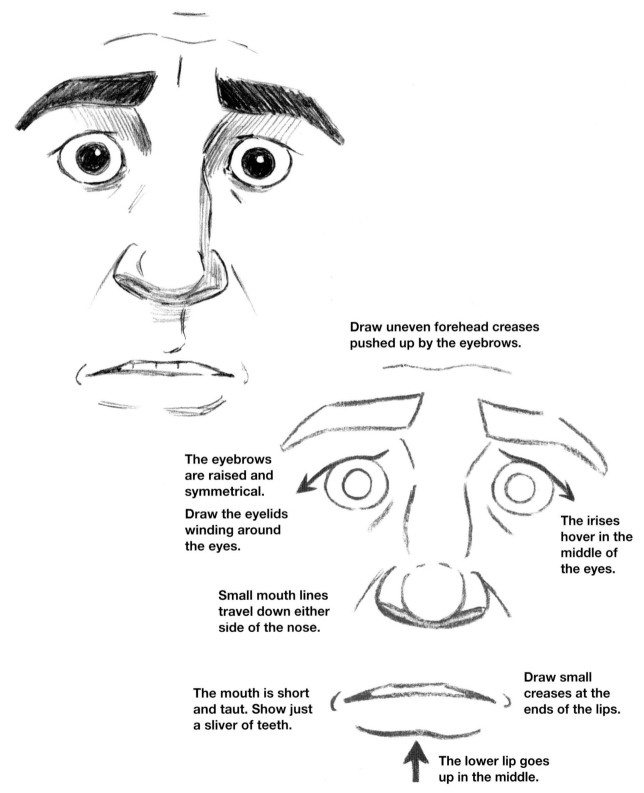

Draw uneven forehead creases pushed up by the eyebrows.

The eyebrows are raised and symmetrical.

Draw the eyelids winding around the eyes.

The irises hover in the middle of the eyes.

Small mouth lines travel down either side of the nose.

The mouth is short and taut. Show just a sliver of teeth.

Draw small creases at the ends of the lips.

The lower lip goes up in the middle.

73

Anxious

Although it's a common emotion, anxiety doesn't communicate much information. However, if we also show the eyes focused on something, that suggests a story, which may be more interesting to the viewer.

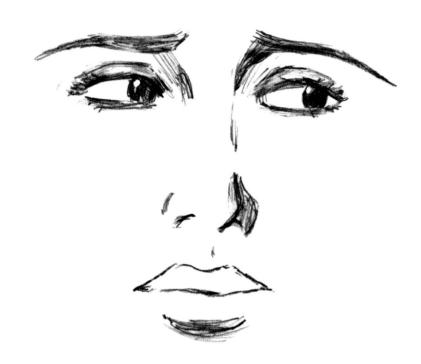

The eyebrows go up, but not in a straight line.

Draw the eyelids on top of the eyes, like coverings.

Do some "spot shading" on either side of the bridge of the nose.

The horizontal line of the lips is drawn with a gentle dip in the center.

Buoyant

It's an understandable assumption that a happy expression only requires manipulating the mouth. But the mouth requires support from the other features in order to make the smile engaging. To create an appealing expression, we have to turn to the eyes. This will help us convey a sense of anticipation, which adds more story to the attitude.

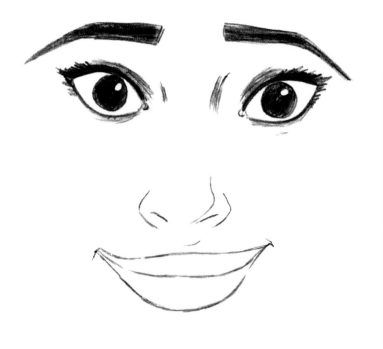

Alternative Eyes

Many eye types can look cheerful. This pair is sleeker but no less cheerful. That quality is created by the upper and lower eyelids pressing on the eyeballs.

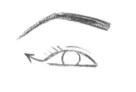 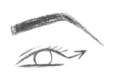

FACE FACTS

When the eyes are drawn large, the mouth doesn't have to work as hard.

Both eyebrows rise on a curve but remain at the same level. You should be able to draw an arching guideline to connect one to the other.

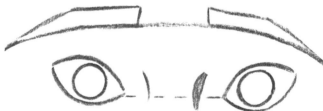

The eyeballs widen.

Lower the tear ducts slightly, but make sure they're on the same level.

I prefer a smaller smile because it suggests that the character is thinking, whereas a larger smile is more reactive.

Bad Intentions

When someone is mad, they frown. If they're out for revenge, they frown and smile. This is a fun expression to draw because it creates a big personality. But it's easy to overdo. If the eyebrows are too severe or the smile too vibrant, it can become a caricature. By slightly underplaying it, you allow the viewer to wonder about the character's intentions.

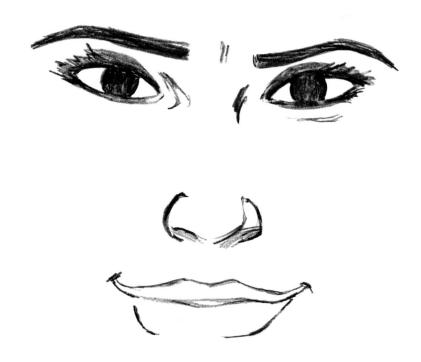

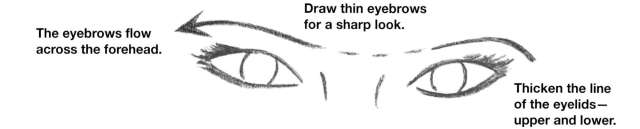

The eyebrows flow across the forehead.

Draw thin eyebrows for a sharp look.

Thicken the line of the eyelids— upper and lower.

Create a small opening in the middle of the lower lip to convey the idea that she is considering something.

The line of the mouth curls up at the ends.

For a stylized touch, you can omit some of the line of the bottom lip.

Two Smiles

Sometimes, you can take an expression, make a small change to it, and create a completely different attitude. This technique could save you the trouble of reinventing something from scratch when a small adjustment would do the trick. Try one or both of the expressions and see what you come up with.

Feeling Certain

The smile is nondescript, but the prominent eyebrows give this guy a knowing expression. The smile becomes a reflection of his inner certainty.

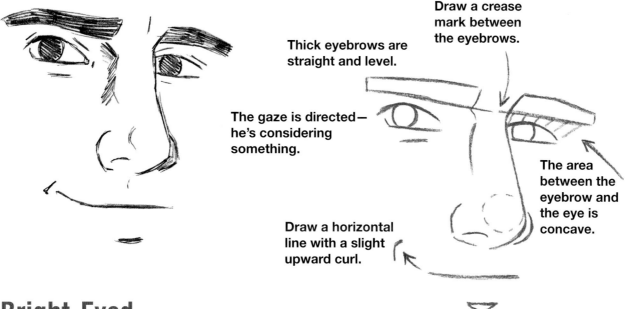

Draw a crease mark between the eyebrows.

Thick eyebrows are straight and level.

The gaze is directed—he's considering something.

The area between the eyebrow and the eye is concave.

Draw a horizontal line with a slight upward curl.

Bright-Eyed

The above expression was primarily driven by the eyebrows. This one is primarily driven by the eyes. Interestingly, the smile is still a minor player.

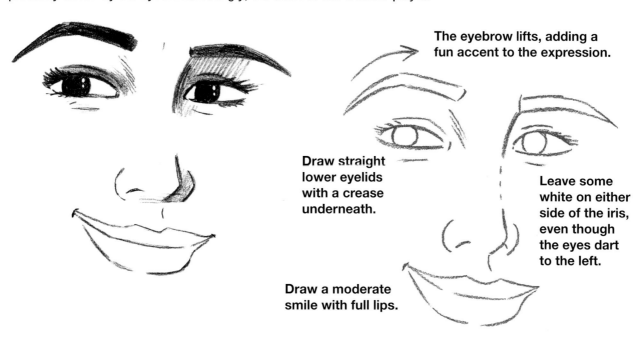

The eyebrow lifts, adding a fun accent to the expression.

Draw straight lower eyelids with a crease underneath.

Leave some white on either side of the iris, even though the eyes dart to the left.

Draw a moderate smile with full lips.

Optimistic

We'll now draw expressions along with the complete outline of the head and face. You'll get to see that expressions are often the defining element of interesting characters. For example, an optimistic personality can be indicated with a subdued smile. It becomes part of an optimistic character. Let's give it a try, step by step.

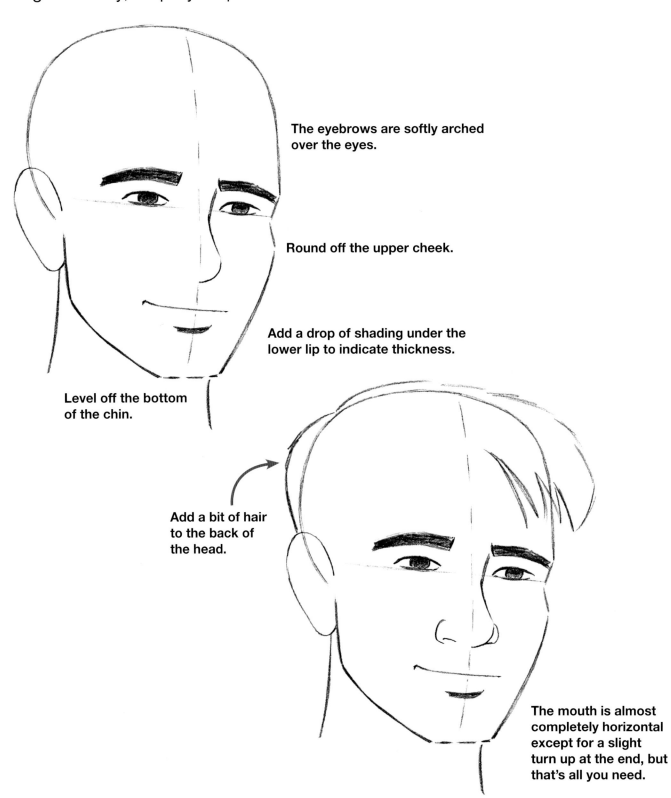

The eyebrows are softly arched over the eyes.

Round off the upper cheek.

Add a drop of shading under the lower lip to indicate thickness.

Level off the bottom of the chin.

Add a bit of hair to the back of the head.

The mouth is almost completely horizontal except for a slight turn up at the end, but that's all you need.

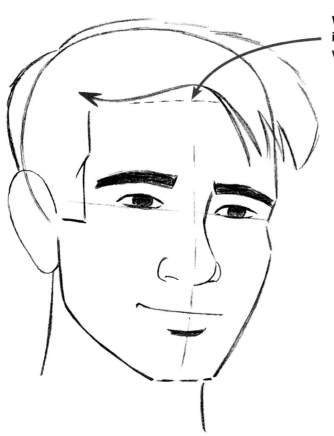

When hair flips over the head, it creates a gap that gets filled with shadow.

Upbeat Eyes

The curves that define the eyebrows and the eyes create an upbeat look. Curved lines tend to look cheerful.

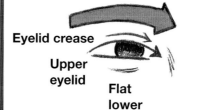

Eyebrow curve

Eyelid crease

Upper eyelid

Flat lower eyelid

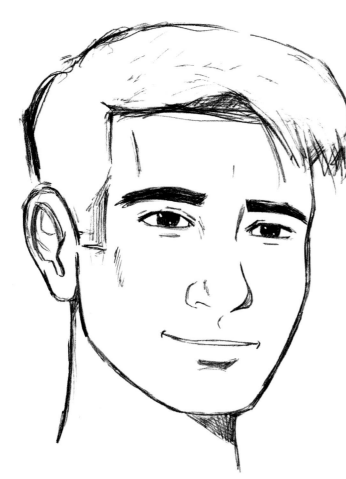

Sketchiness adds spontaneity. I lean toward cleaned-up sketches, which are closer to a finished drawing than they are to an initial rough.

Amused

An amused expression adds a cute attitude to a smile. It's understated but fun, good-natured but slightly mischievous. The features are drawn with the same principles of more charged expressions, but the decibels are reduced.

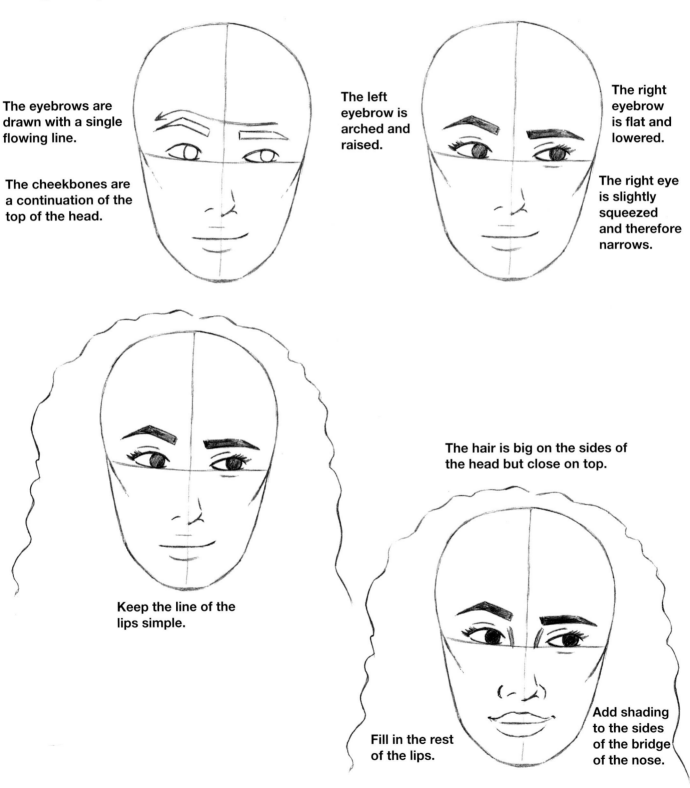

The eyebrows are drawn with a single flowing line.

The cheekbones are a continuation of the top of the head.

The left eyebrow is arched and raised.

The right eyebrow is flat and lowered.

The right eye is slightly squeezed and therefore narrows.

Keep the line of the lips simple.

The hair is big on the sides of the head but close on top.

Fill in the rest of the lips.

Add shading to the sides of the bridge of the nose.

The Squeeze

The eyebrow pushes down on the eye, while at the same time, the crease under the eye pushes up, squeezing it.

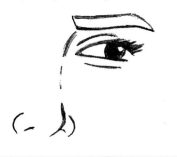

Leave room between the eyes and the hair (on the sides) so that the face doesn't appear cluttered.

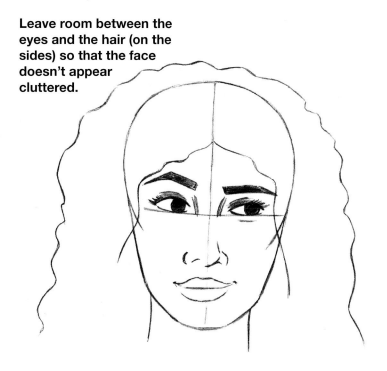

Shading eyelids is not solely an aesthetic technique. It's also used to draw attention to the eyes.

Two reflective glints in each eye show a character who is thinking.

Black earrings create contrast.

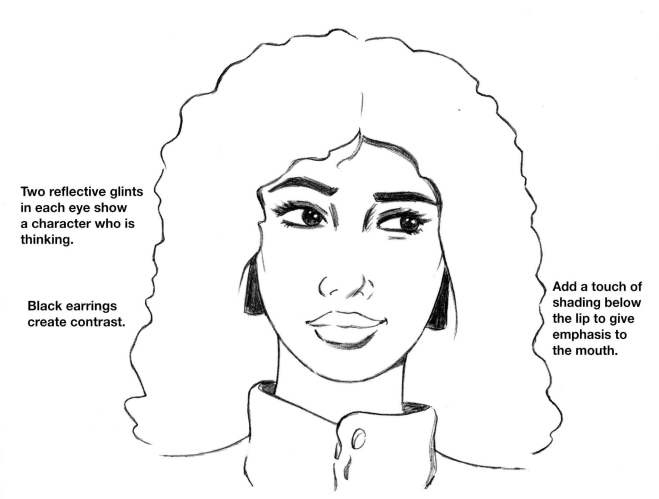

Add a touch of shading below the lip to give emphasis to the mouth.

Grief

At first you might think that no one wants to see grief. It's a tough emotion. But portraying grief forces the viewer to feel his or her humanity, while staying a safe distance from it. Isn't that part of what art is about? Because grief is a big emotion, you either have to put a lot of pressure on the features, or let the tilt of the head do some of the work, as we'll do here.

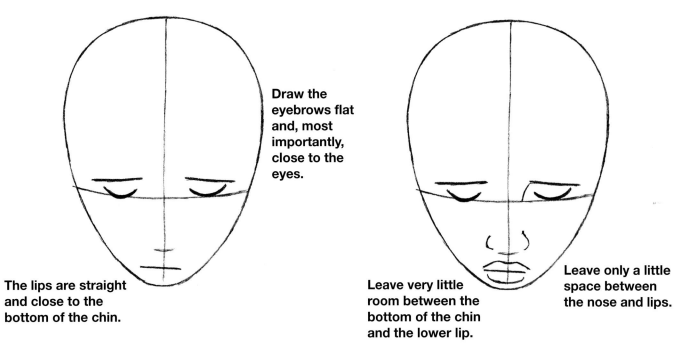

Draw the eyebrows flat and, most importantly, close to the eyes.

The lips are straight and close to the bottom of the chin.

Leave very little room between the bottom of the chin and the lower lip.

Leave only a little space between the nose and lips.

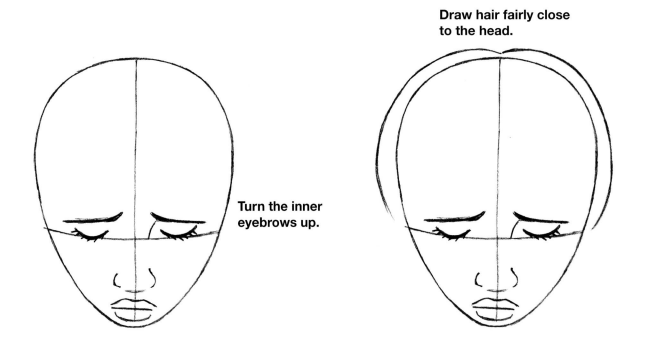

Turn the inner eyebrows up.

Draw hair fairly close to the head.

Center the hair bun over the part.

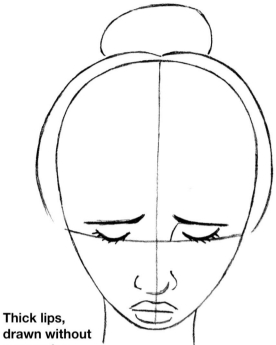

Thick lips, drawn without expression, convey grief.

Check to make sure that the chin is centered within the neck.

Hair falls over the head randomly, carelessly.

Shade the eyelids to bring intensity to that area.

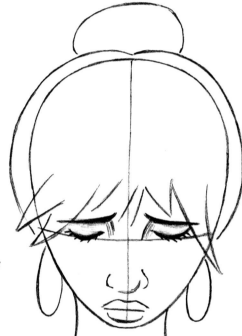

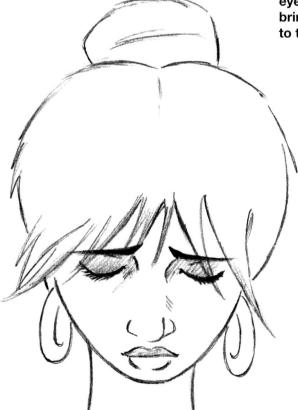

By tilting the head downward, you create a private moment for the character, while allowing your viewer in.

Sympathetic

This look combines two different expressions in order to produce a third, different look. The eyes are worried, but the mouth is smiling. The result is an emotion that is both caring and encouraging. Let's give it a try.

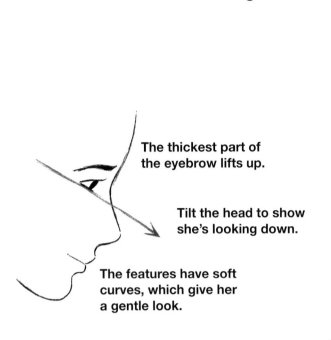

The thickest part of the eyebrow lifts up.

Tilt the head to show she's looking down.

The features have soft curves, which give her a gentle look.

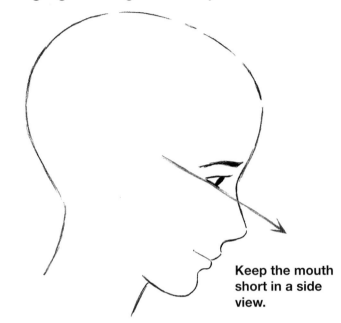

Keep the mouth short in a side view.

FACE FACTS
The back of the skull ends at about the same level as the bottom of the nose.

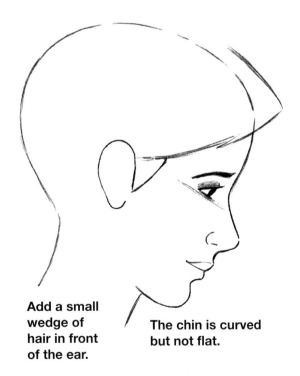

Add a small wedge of hair in front of the ear.

The chin is curved but not flat.

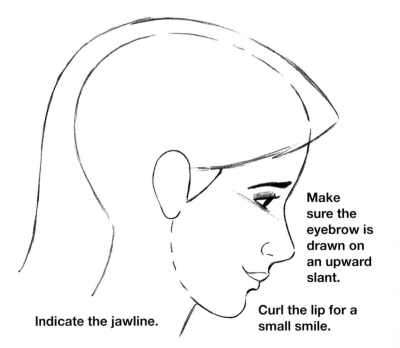

Make sure the eyebrow is drawn on an upward slant.

Curl the lip for a small smile.

Indicate the jawline.

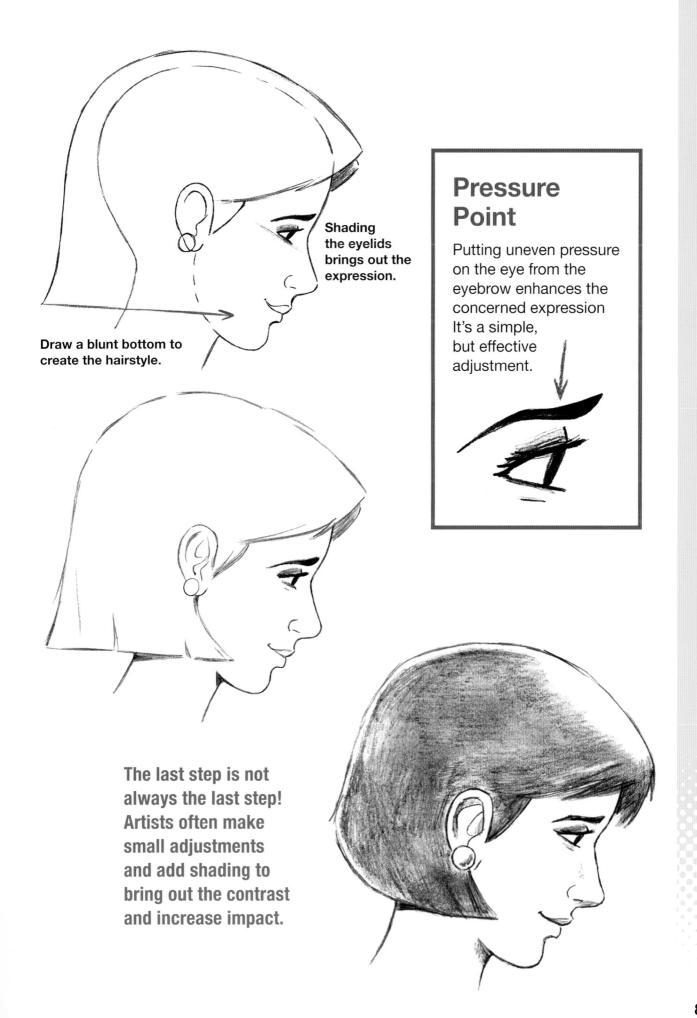

Shading the eyelids brings out the expression.

Draw a blunt bottom to create the hairstyle.

Pressure Point

Putting uneven pressure on the eye from the eyebrow enhances the concerned expression It's a simple, but effective adjustment.

The last step is not always the last step! Artists often make small adjustments and add shading to bring out the contrast and increase impact.

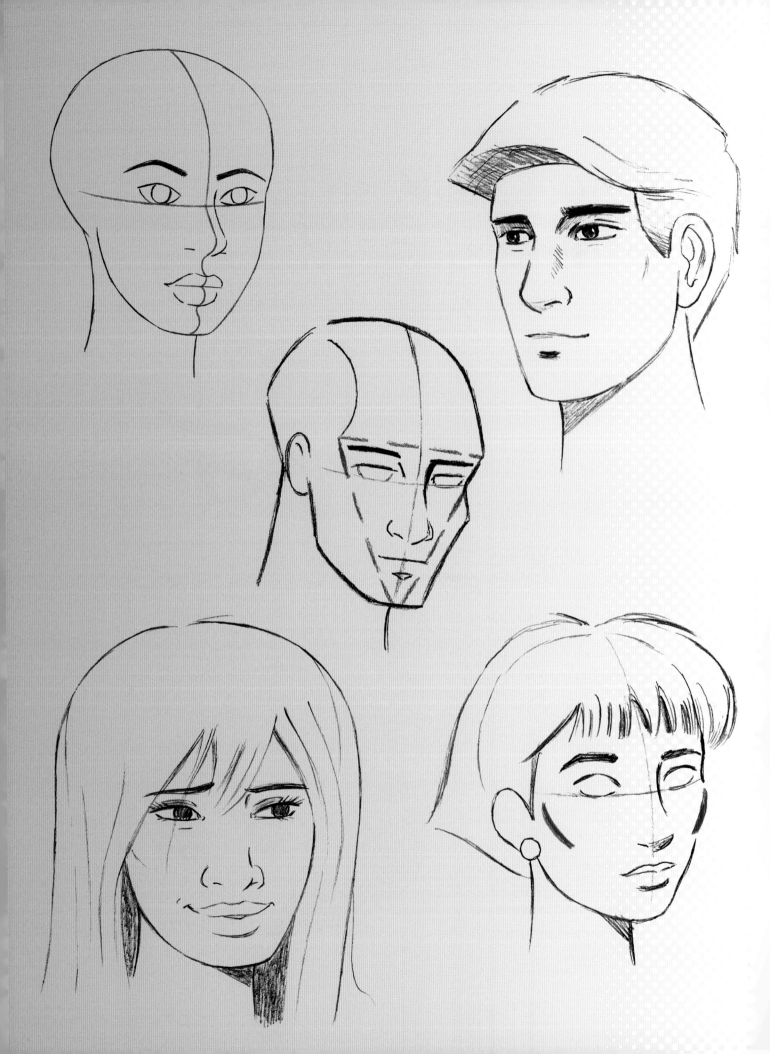

Raise Your Level!

So far in this book, we have covered essential techniques for getting started drawing faces. Now we'll take it a step further. I'll introduce you to practical techniques that can give your drawings the edge you've been looking for. The concepts are as easy to grasp as they were in the previous chapters but add a touch of refinement. In my experience, many aspiring artists possess an innate ability to draw, but lack information. This section will provide it. Let's dig in.

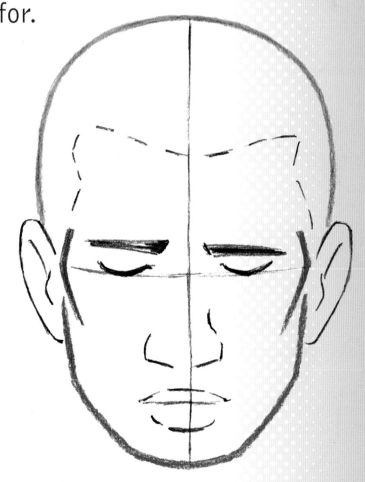

The Area of Interest

We usually think of the face as a small section—represented by a triangle. Anything outside of the triangle has less impact on the viewer. This is important for prioritizing our efforts, specifically where we put detail and shading. Let's see how it works at various angles.

Front

The front view commands attention at the center of the face and narrows as it tapers to the chin.

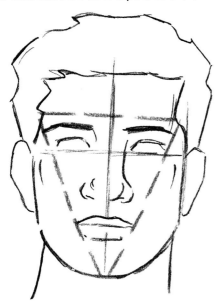

Three-Quarter View—Left

Because the face is turned left, the left half of the triangle will appear slightly narrower and the right half will appear fuller.

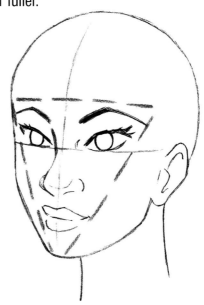

Three-Quarter View—Right

When the face is turned to the right, the left half of the triangle is larger.

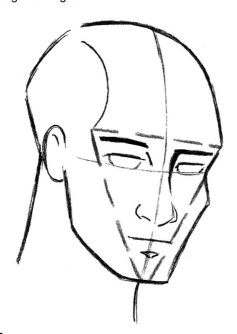

Profile

In the side view, the center of interest is quite narrow.

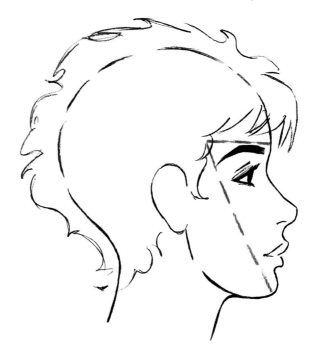

Area of Interest: Step by Step

Now let's draw a face in the front view. The area of interest lies within the triangle. That's where you should spend the most time and include the most detail.

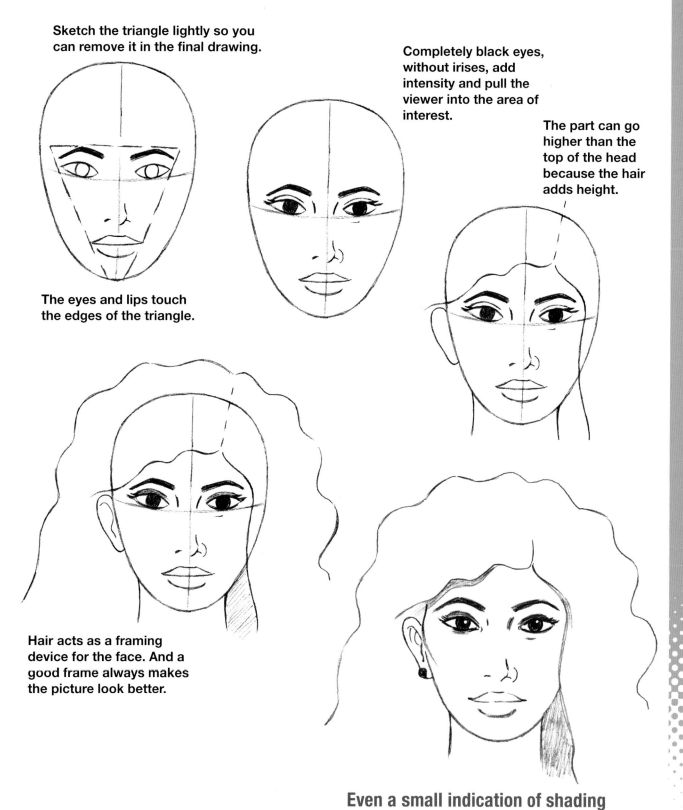

Sketch the triangle lightly so you can remove it in the final drawing.

The eyes and lips touch the edges of the triangle.

Completely black eyes, without irises, add intensity and pull the viewer into the area of interest.

The part can go higher than the top of the head because the hair adds height.

Hair acts as a framing device for the face. And a good frame always makes the picture look better.

Even a small indication of shading prevents the image from looking empty.

89

Surface Variations

Most artists are taught to begin a face like this, with a vertical and horizontal guideline. It's practical and works, but it implies that the face is a flat surface, which it isn't. We need an understanding of dimensions.

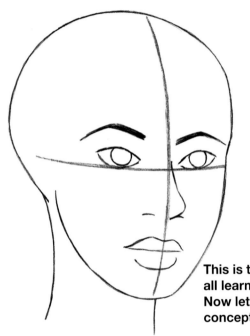

This is the way we all learn to draw. Now let's widen our concept.

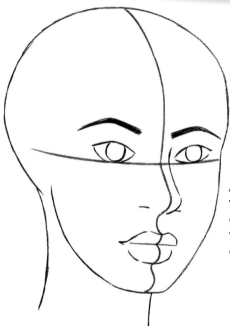

As the guideline follows the contours of the face, the flatness begins to disappear.

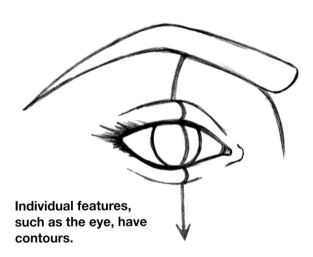

Individual features, such as the eye, have contours.

The curving guidelines are embedded in the foundation of every face.

Straight Guidelines

The contoured guideline is meant to demonstrate that the surface of the face is uneven. We can return to the straight guideline as a quick and practical way to start a drawing, as long as we keep the principle of contours in mind.

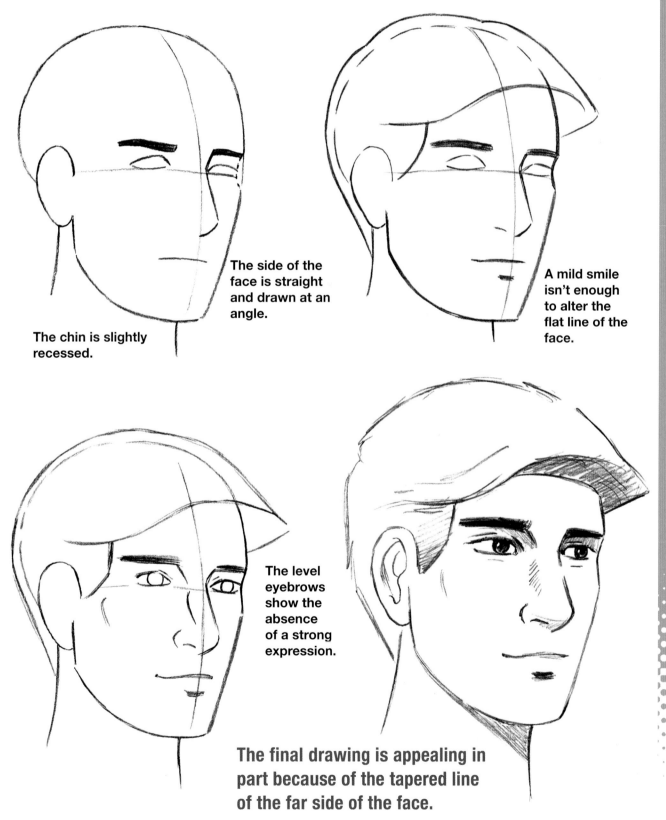

The side of the face is straight and drawn at an angle.

The chin is slightly recessed.

A mild smile isn't enough to alter the flat line of the face.

The level eyebrows show the absence of a strong expression.

The final drawing is appealing in part because of the tapered line of the far side of the face.

Contours

Expressions, especially big ones, distort the edge of the face so that it's no longer straight. In a smile, the cheek balls up, causing the chin to be more pronounced. Were you to draw the same smile without adjusting the contours, the expression would appear oddly lifeless. Contours and expressions work hand in hand.

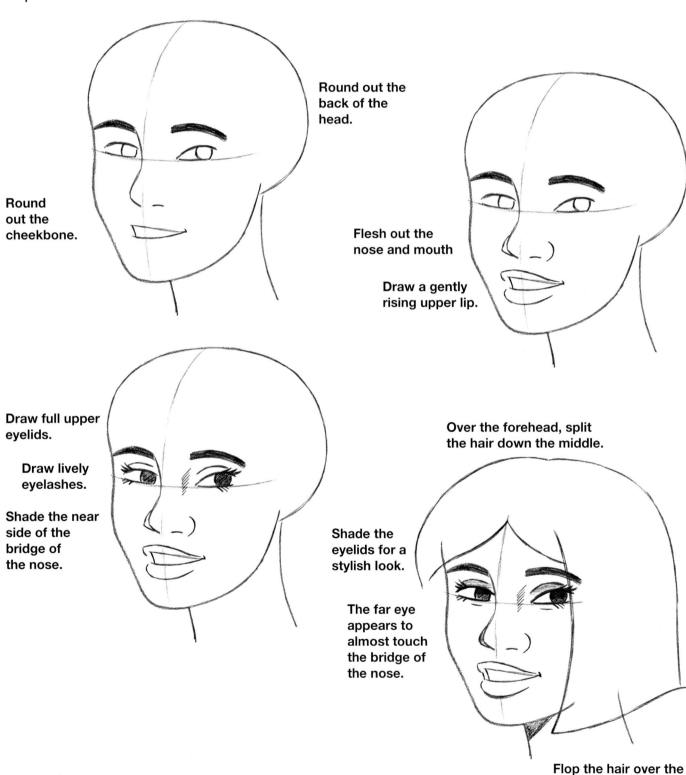

Round out the back of the head.

Round out the cheekbone.

Flesh out the nose and mouth

Draw a gently rising upper lip.

Draw full upper eyelids.

Draw lively eyelashes.

Shade the near side of the bridge of the nose.

Over the forehead, split the hair down the middle.

Shade the eyelids for a stylish look.

The far eye appears to almost touch the bridge of the nose.

Flop the hair over the near side of the face.

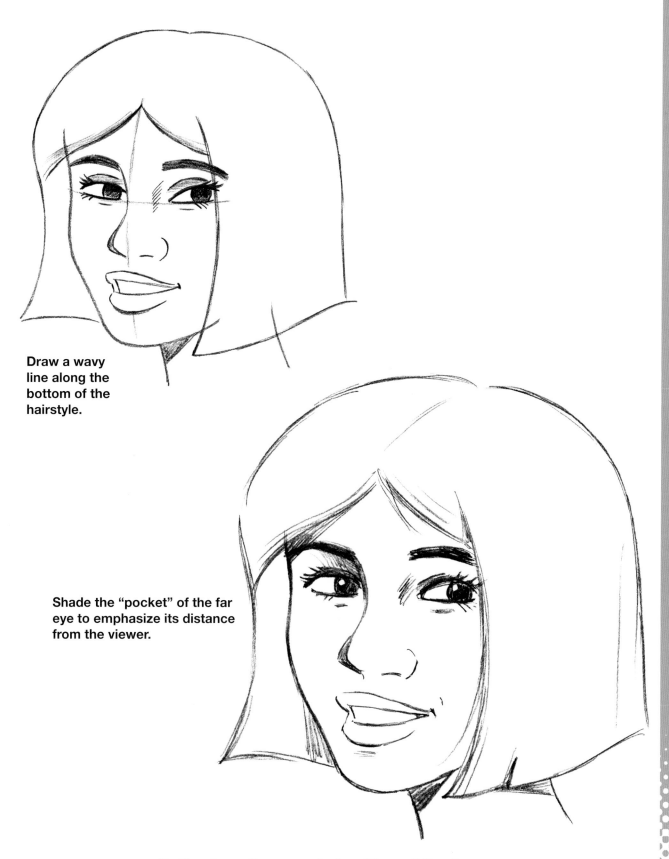

Draw a wavy line along the bottom of the hairstyle.

Shade the "pocket" of the far eye to emphasize its distance from the viewer.

Notice how the rounded outline of the face conveys joy just as effectively as the smile does. In this way, the features combine with the outline of the head to communicate a feeling. That's what drawing expressions is all about.

More Hidden Guidelines

In the first chapter, we looked at a number of important guidelines for drawing the face. Here are few subtler guidelines that will give your drawings an extra edge.

Lower Face

This guideline is a particularly useful reminder that the face is drawn at a forward angle, not up and down.

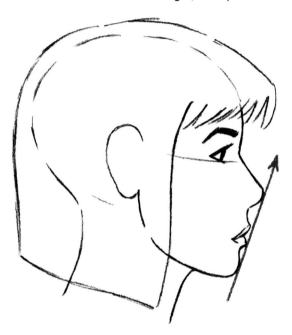

Diagonal Lines

There are three diagonals that appear on the profile. These can be adjusted to fit specific contours or expressions.

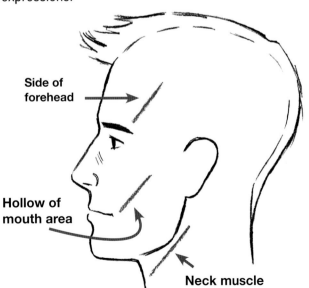

Side of forehead

Hollow of mouth area

Neck muscle

Cut It Out

The test of how well a guideline works is when you erase it. If the drawing looks better, keep the technique.

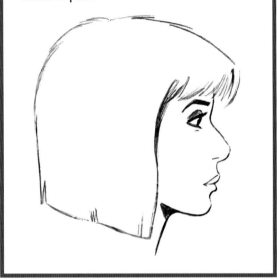

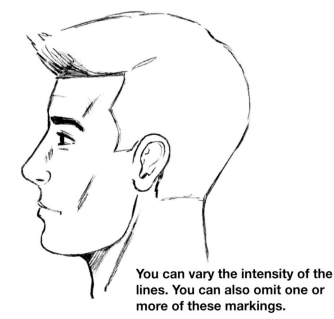

You can vary the intensity of the lines. You can also omit one or more of these markings.

Parallel Curves

The inner edge of the forehead runs parallel to the outer edge of the forehead.

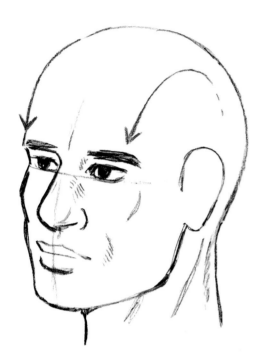

Connect Contour Lines

When you have two defining lines in close proximity to each other, try to connect them. A longer, winding line is more pleasing to the eye than two short lines.

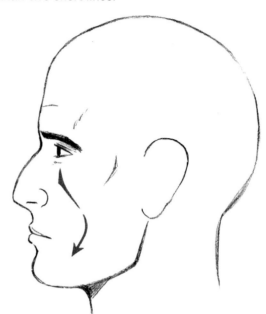

Adjusting the Foundation Shape

The starting place for many heads is an egg. But it needs to be developed.

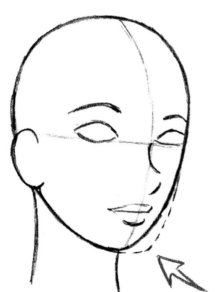

Add some mass.

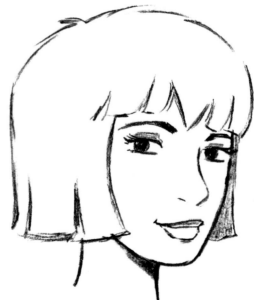

Framing the Face: Cheekbones

The cheekbones are the widest part of the face. They act as bookends, giving the face a strong and stable appearance. Even when the head changes angles, such as in this "down" view, the cheekbones hold it together. They can also be used to enhance the aesthetics, which we'll see in the next couple of pages. But first, let's find out where they're placed and how to draw them.

Simple Diagram

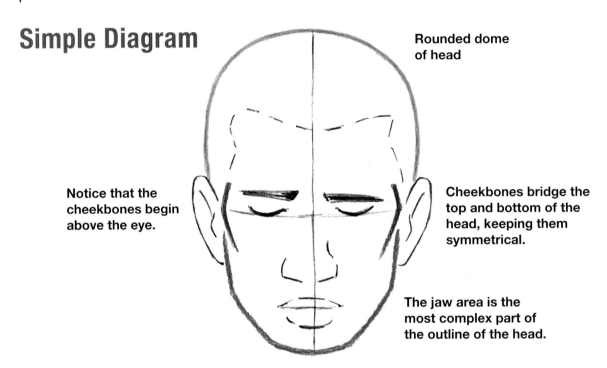

Rounded dome of head

Notice that the cheekbones begin above the eye.

Cheekbones bridge the top and bottom of the head, keeping them symmetrical.

The jaw area is the most complex part of the outline of the head.

Trying It Out, Step by Step

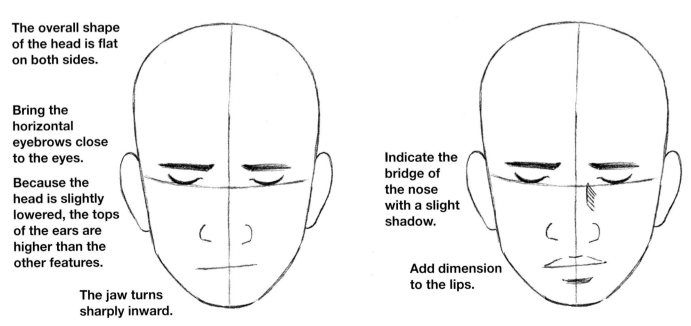

The overall shape of the head is flat on both sides.

Bring the horizontal eyebrows close to the eyes.

Because the head is slightly lowered, the tops of the ears are higher than the other features.

The jaw turns sharply inward.

Indicate the bridge of the nose with a slight shadow.

Add dimension to the lips.

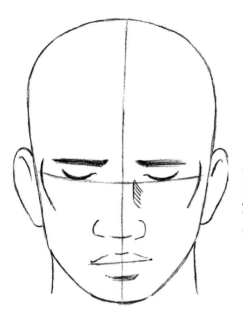

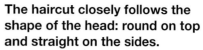
The haircut closely follows the shape of the head: round on top and straight on the sides.

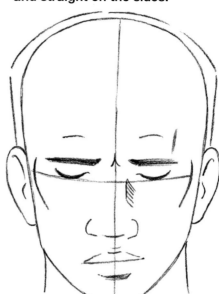

Align the cheekbones just inside the outline of the face.

The interior hairline dips in the middle.

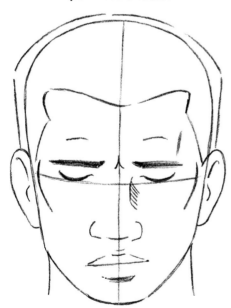

With a minimal number of expression lines, the cheekbones are prominent.

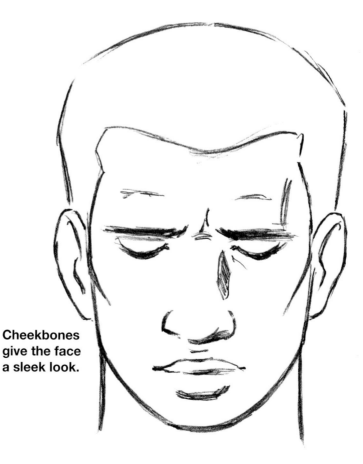

Cheekbones give the face a sleek look.

Cheekbones & Aesthetics

Cheekbones can be used to highlight the eyes. By raising the cheekbones, you create a prominent platform for the eyes, drawing attention to them. In addition, cheekbones can appear to stretch the face, resulting in a sleek look.

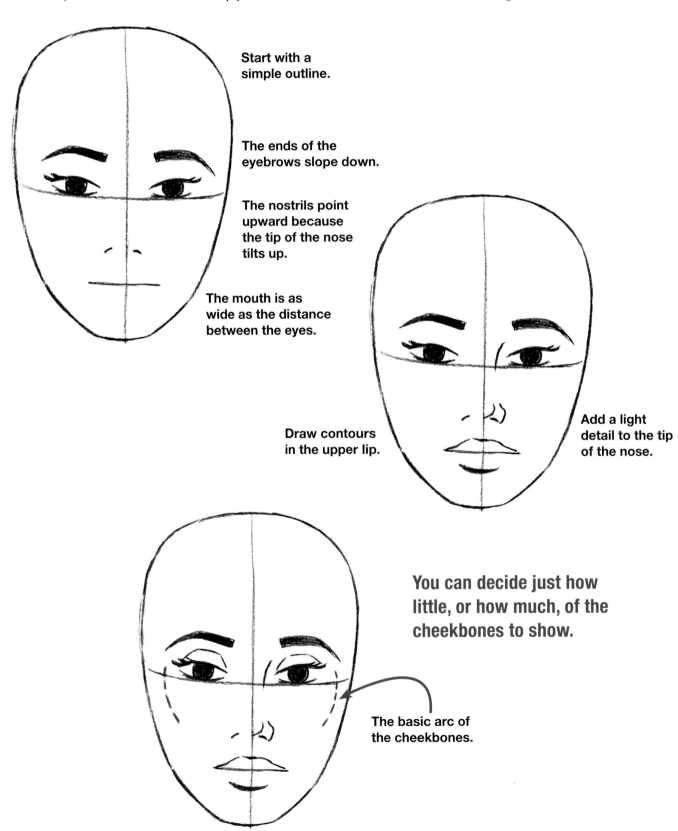

Start with a simple outline.

The ends of the eyebrows slope down.

The nostrils point upward because the tip of the nose tilts up.

The mouth is as wide as the distance between the eyes.

Draw contours in the upper lip.

Add a light detail to the tip of the nose.

You can decide just how little, or how much, of the cheekbones to show.

The basic arc of the cheekbones.

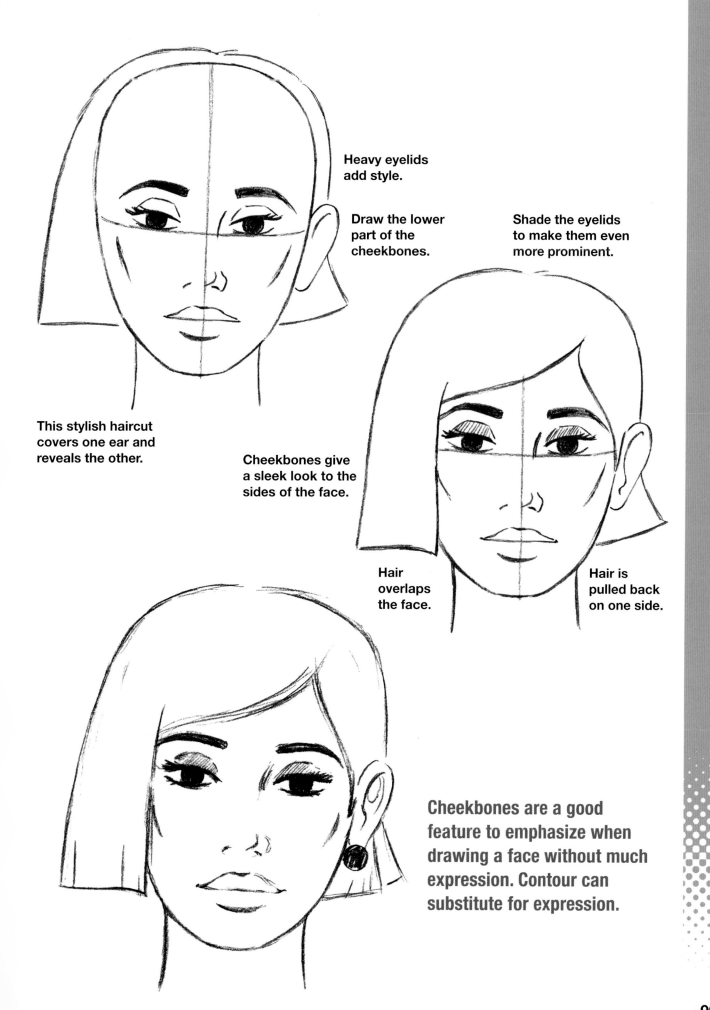

Heavy eyelids add style.

Draw the lower part of the cheekbones.

Shade the eyelids to make them even more prominent.

This stylish haircut covers one ear and reveals the other.

Cheekbones give a sleek look to the sides of the face.

Hair overlaps the face.

Hair is pulled back on one side.

Cheekbones are a good feature to emphasize when drawing a face without much expression. Contour can substitute for expression.

Cheekbones: Three-Quarter View

The cheekbone begins a couple of notches to the left of the eye, not directly below it. If you were to draw it closer, it would cause the face to look narrow. All faces have fully formed cheekbones, but not all of them are pronounced.

Three-Quarter View Right

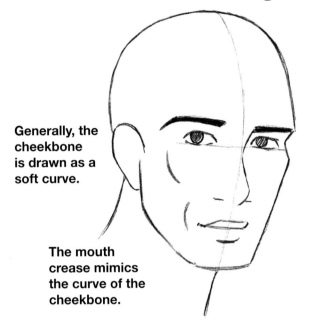

Generally, the cheekbone is drawn as a soft curve.

The mouth crease mimics the curve of the cheekbone.

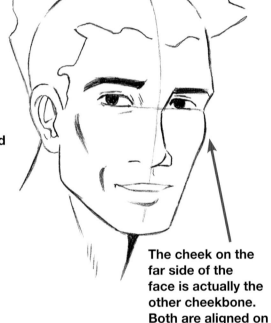

A light slash is all you need to define the cheekbone.

The cheek on the far side of the face is actually the other cheekbone. Both are aligned on the same level.

Three-Quarter View Left

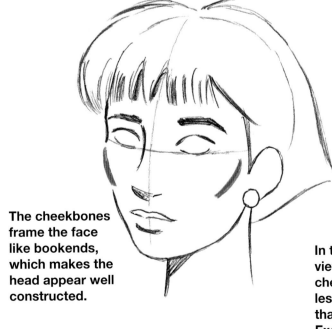

The cheekbones frame the face like bookends, which makes the head appear well constructed.

In the three-quarter view, the far cheekbone is usually less articulated than the near one. Exceptions are craggy, bony faces.

Cheekbones: More Angles

Cheekbones take on a different appearance in the profile. They can look plump, such as when they're pushing up a cheek. Or they can look flat, creating a rugged expression.

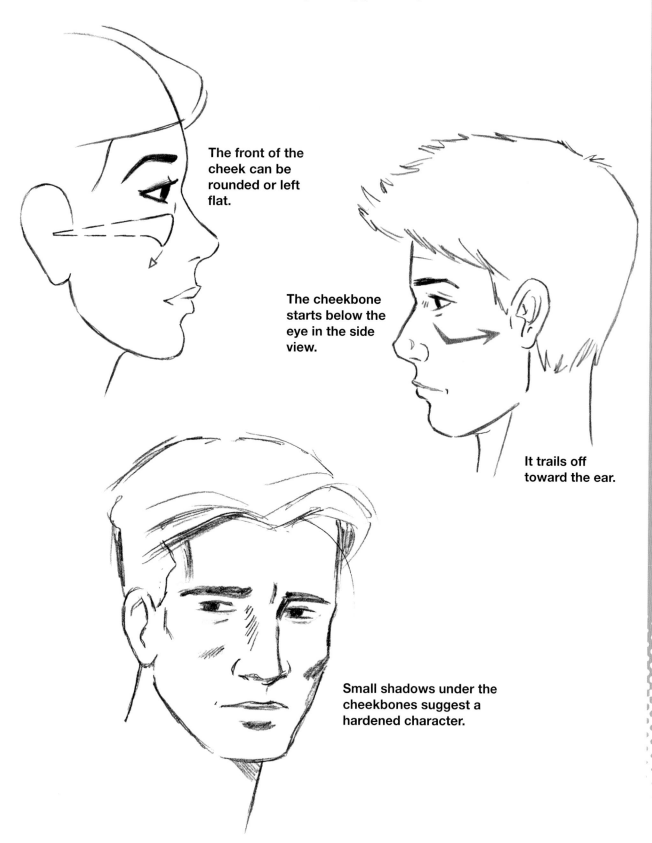

The front of the cheek can be rounded or left flat.

The cheekbone starts below the eye in the side view.

It trails off toward the ear.

Small shadows under the cheekbones suggest a hardened character.

How the Cheekbones Affect the Face

When cheekbones protrude, they tend to create a slightly hollow area below them. This sunken look can be lightly indicated with shading. If you'd rather only indicate the cheekbones, that's fine, too.

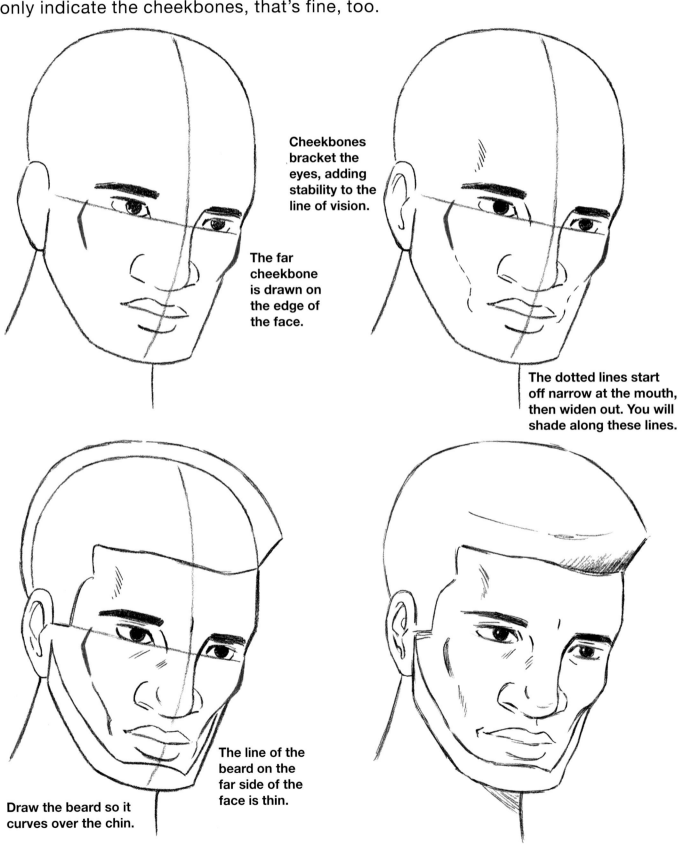

Cheekbones bracket the eyes, adding stability to the line of vision.

The far cheekbone is drawn on the edge of the face.

The dotted lines start off narrow at the mouth, then widen out. You will shade along these lines.

Draw the beard so it curves over the chin.

The line of the beard on the far side of the face is thin.

Cheekbones as Accents

The empty space between the outline of the head and the features may cause an image to flatten. There's an easy way to remedy it. Draw an indication of cheekbones. Cheekbones instantly suggest contours to the face, creating a rounded look.

Starting Point

Here's our subject without cheekbones. The face is well proportioned and cheerful, but it's a bit flat. Nothing seems to protrude or recede. It could use some cheekbones and a little shading.

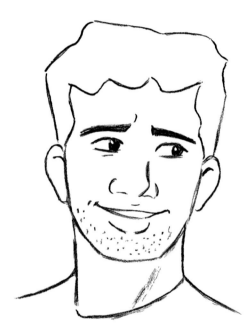

With Cheekbones

Notice that the cheekbones are the widest part of the face, and symmetrical on both sides. They're simple curved lines. You can draw them easily.

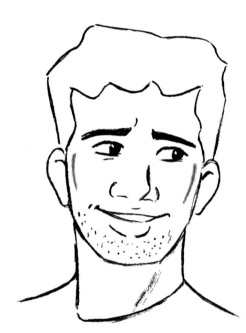

Shaded Drawing

There are two intensities of lines in this picture: black and gray. Gray is a good tone for suggesting contours. Black works better to define the outline of a shape.

Draw the cheekbones lightly, because if you use a lot of emphasis, the cheekbones will define a character type (like a severe personality) rather than define a shape.

The Jawline

The dome of the head is similar on most people because it's just a curved line. But the lower half of the head, which contains the jaw and chin, has numerous angles and varies according to each individual. Therefore, instead of focusing only on the features to create different faces, we'll also utilize the structure of the head itself.

A Balanced Look

The jaw needs to look even. These guidelines can help when laying out an initial sketch. The angle of the left line should be the same as the one on the right.

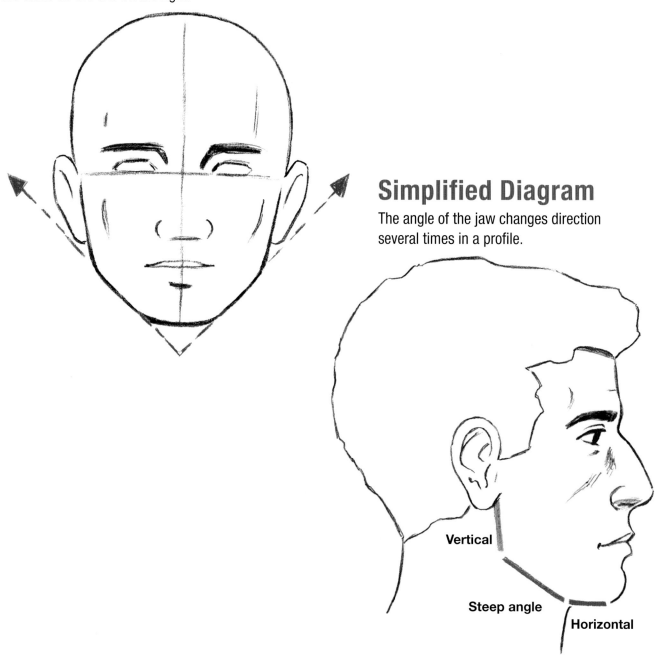

Simplified Diagram

The angle of the jaw changes direction several times in a profile.

Vertical

Steep angle

Horizontal

Looking for Angles

The near side of the face has a number of angles located along the jaw, whereas the far side of the face is padded, which conceals the angles. Treating the two sides of the face differently creates contrast.

Changing Directions

The lower part of the face has three angles: vertical, diagonal, and horizontal. Each can be lessened or increased in degree to create individuals.

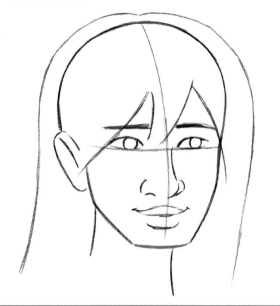

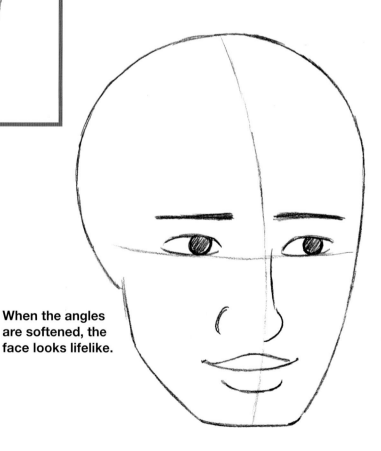

When the angles are softened, the face looks lifelike.

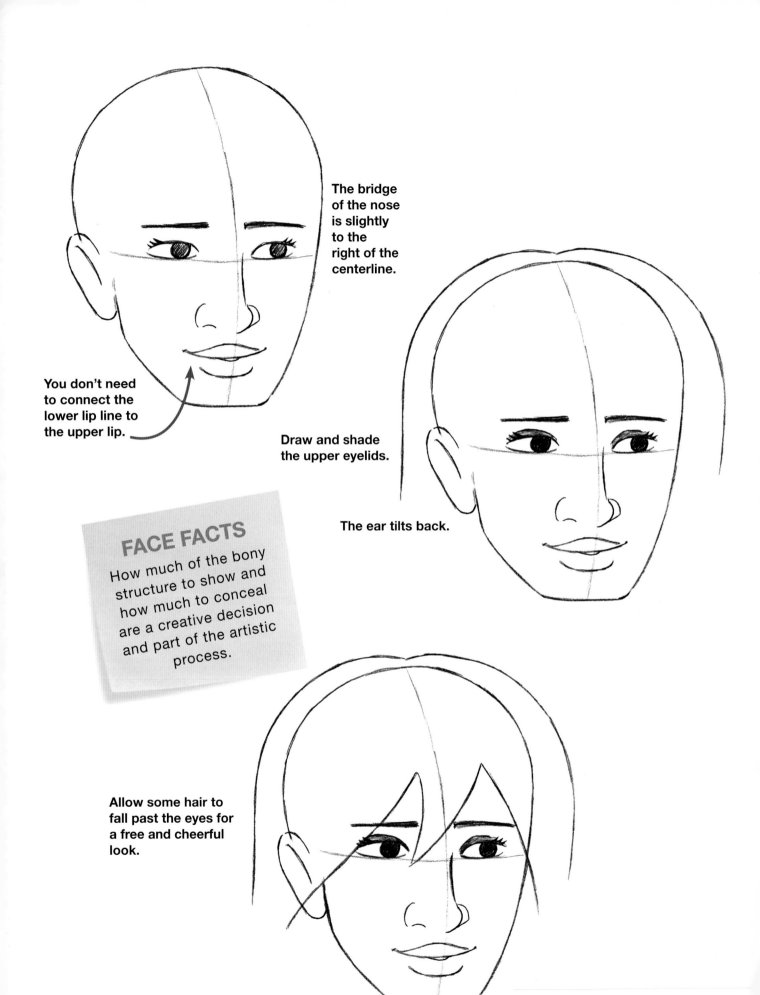

The bridge of the nose is slightly to the right of the centerline.

You don't need to connect the lower lip line to the upper lip.

Draw and shade the upper eyelids.

FACE FACTS
How much of the bony structure to show and how much to conceal are a creative decision and part of the artistic process.

The ear tilts back.

Allow some hair to fall past the eyes for a free and cheerful look.

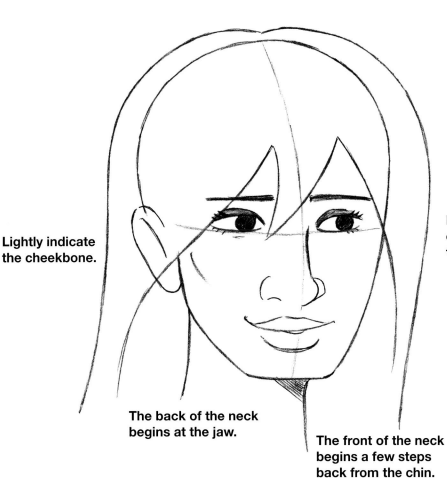

Lightly indicate the cheekbone.

Draw short eyelashes on the top and bottom.

The back of the neck begins at the jaw.

The front of the neck begins a few steps back from the chin.

Finishing Touches

Now, the finishing touches come into play, such as the shaded interior of the hair and its striations. I also drew one strand of hair casually in front of her eyes to make the moment seem spontaneous. I've also added a small mouth crease to emphasize the smile. The eyebrows have been given more upward movement in the center of the forehead. And importantly, I lowered the eyelids onto the eyes, making her appear less energetic and more relaxed.

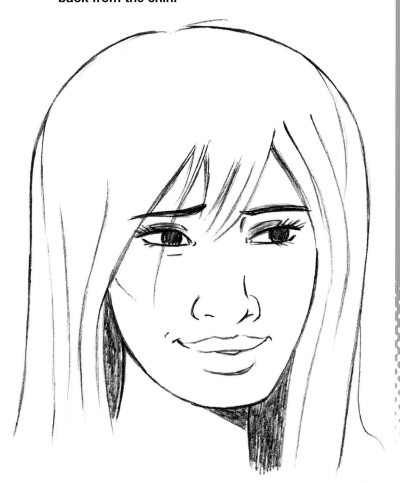

Chin & Jaw Types

Let's try out various chin and jaw types. You'll see how a small adjustment can make a big difference to the look of a face. Experiment with it. You might exaggerate it further or underplay it or take it in an entirely new direction. Perhaps you could base it on someone you know. Just don't show it to them unless you're sure it's flattering. Trust me on this.

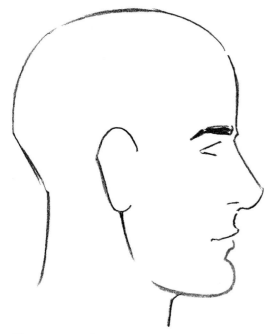

Cupped

This chin type is like half of a tennis ball. It's prominent and makes a bold impression.

Recessed

This chin does not protrude and even angles back.

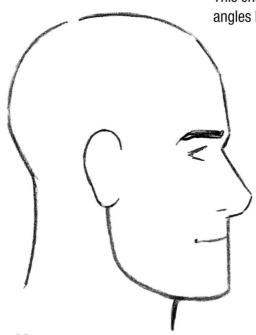

Heavy

This chin is flat in front with a deep jawline. The mouth is minimized.

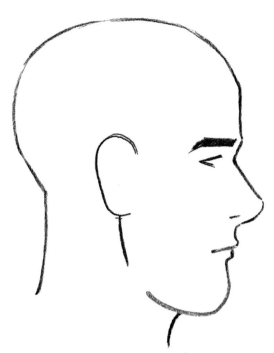

Long

This chin is shaped like any other but is slightly elongated, creating the look of a long face.

Buried

This chin gives the appearance of being somewhat subsumed by a thick neck. Extra bulk is also added to the back of the head.

Square

In this example, the jaw and chin work together to create a right angle. It presents a strong look.

Narrow

The line at the bottom of the jaw creates a sharp angle and a sharp look.

Curved

The curved jawline is a conventional look, but it tends to make the face look narrow.

Change It Up

You don't need to make a big adjustment to change the look of the head.

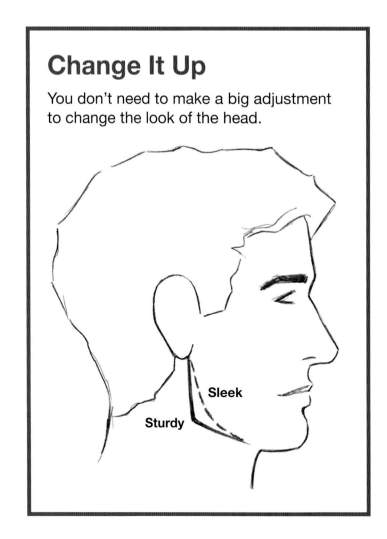

Sleek

Sturdy

Neck Notes

Here's a tip or two about drawing the neck that could come in handy when drawing head shots. These tips will help your poses look natural and easy.

Moving with the Head

The line of the back of the head changes as the head bends forward or back.

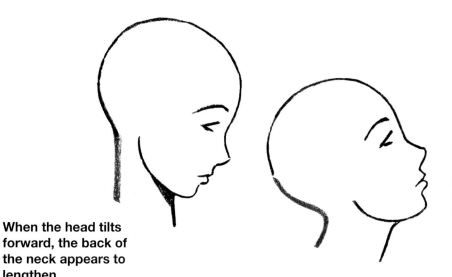

When the head tilts forward, the back of the neck appears to lengthen.

When the head tilts back, the back of the neck is drawn with a deep bend (and the front of the neck curves, too).

Avoiding Straight Lines

The neck can be drawn as two vertical lines. But more often, they're subtly curved.

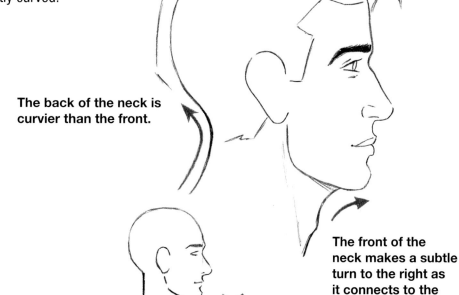

The back of the neck is curvier than the front.

The front of the neck makes a subtle turn to the right as it connects to the underside of the chin.

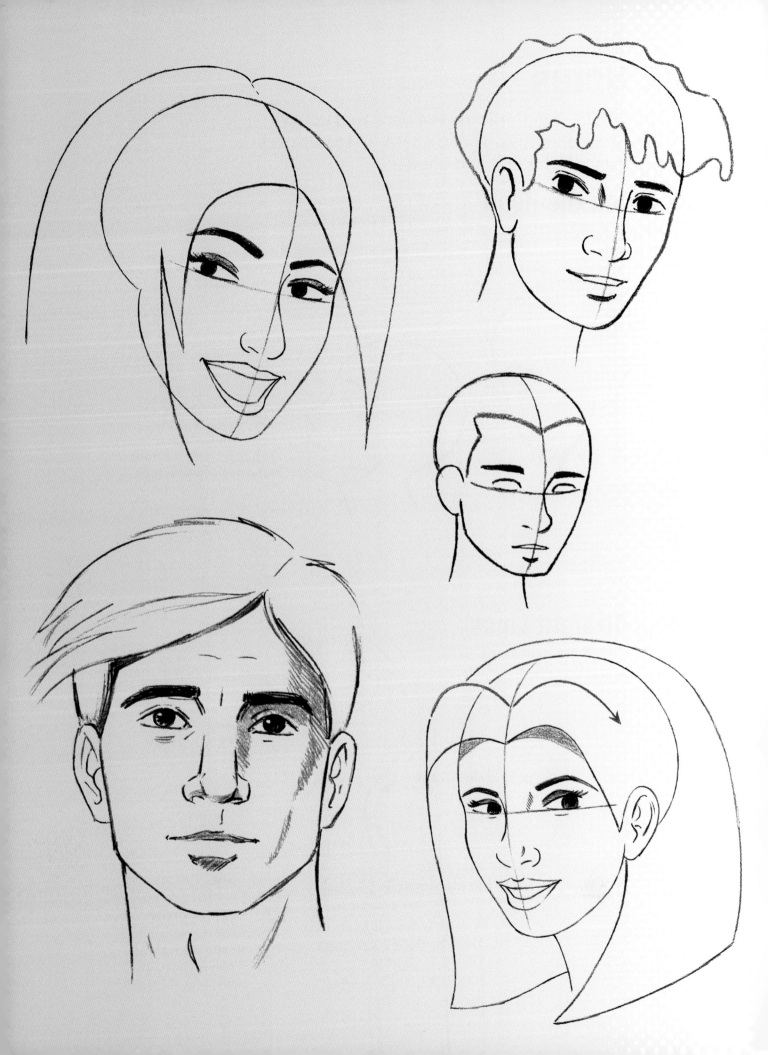

Hairstyles: Complete the Look

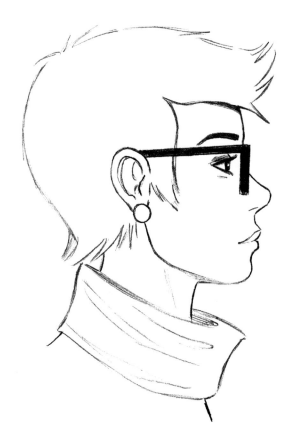

Most hairstyles start with the basic contours of the head, which are simple enough to follow. Once that's in place, individual styles can be created. The techniques we'll use include directionality (or flow), texture, layering, angles, and varying length. Sometimes these vary within the same haircut. Because hair is a fashion statement, I'll demonstrate a variety of popular styles, many of which reflect the personality of the wearer. Have fun with it. Draw from the examples, create a variation, or come up with something entirely new!

Sporty

This is a good look for an active character. The hair flops to one side in a breezy fashion. It's casual and youthful.

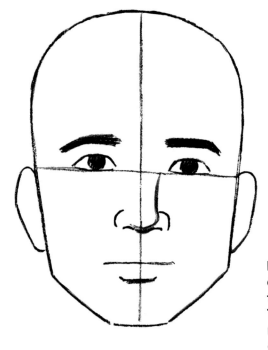

Create enough area on the dome of the head for the hairstyle.

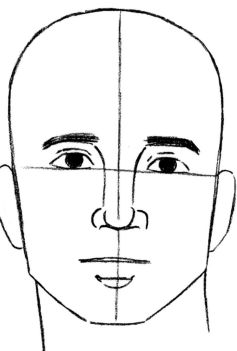

Line up the bridge of the nose along the centerline. The nostrils and mouth are also centered.

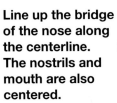

As the hair blows to the left, the right side hugs the head.

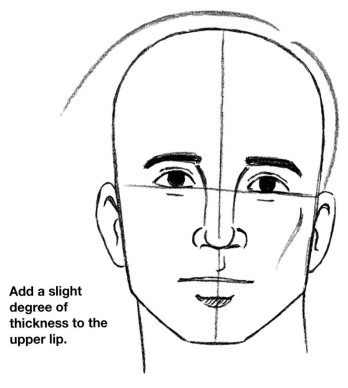

Both eyebrows are drawn on the same level.

Add a slight degree of thickness to the upper lip.

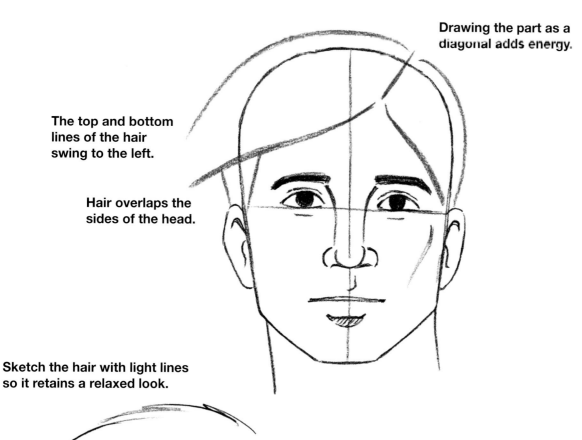

Drawing the part as a diagonal adds energy.

The top and bottom lines of the hair swing to the left.

Hair overlaps the sides of the head.

Sketch the hair with light lines so it retains a relaxed look.

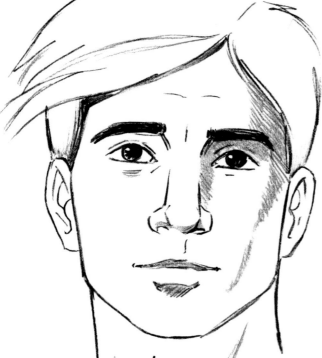

Shadow Play

When you add shading over larger areas, it doesn't need to be as exact as when it's added for accents.

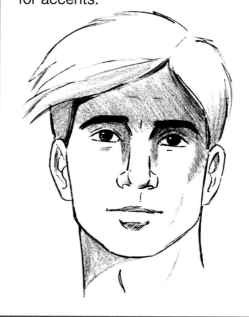

Spontaneous

This hairstyle creates an engaging look. But while it may seem spontaneous, it's not entirely unplanned. Each grouping of hair is placed apart from the others so that they are clearly defined, with variations in length and no overlap.

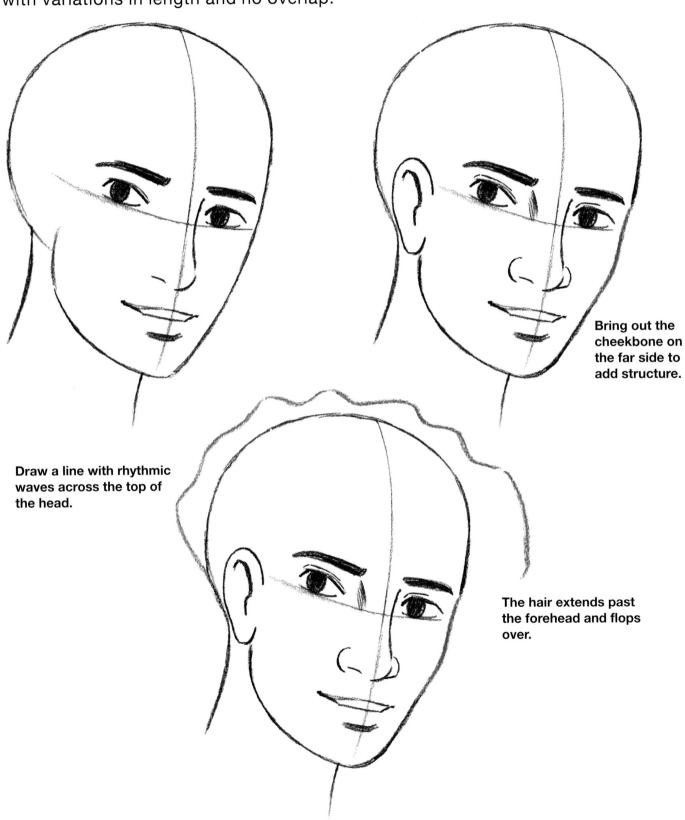

Bring out the cheekbone on the far side to add structure.

Draw a line with rhythmic waves across the top of the head.

The hair extends past the forehead and flops over.

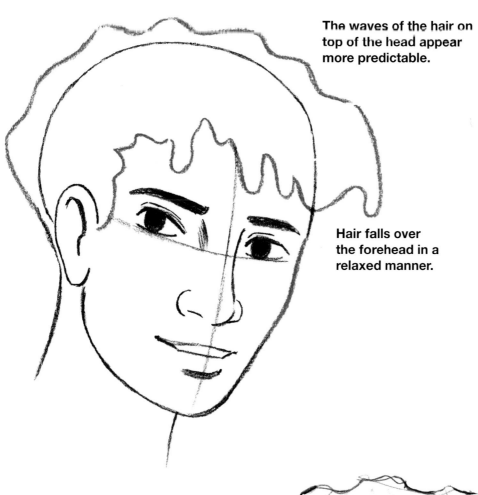

The waves of the hair on top of the head appear more predictable.

Hair falls over the forehead in a relaxed manner.

Most of the stylistic touches appear at the outline—or edges—of the haircut. The underlying basics are similar to other cuts.

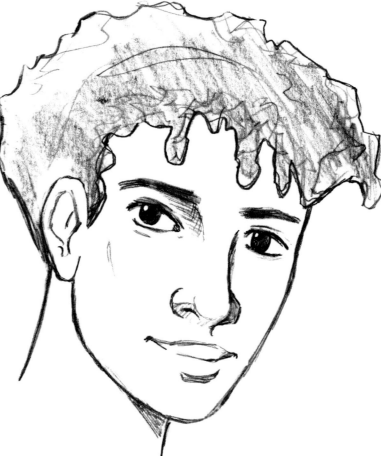

The three-quarter view typically shows the near side and the front of the face and hairstyle.

Giving Hair Thickness

Men's hairstyles are often thick in the front, rising a few inches above the top of the forehead. To draw this popular style effectively, we want to focus on giving it a solid look, and that calls for a flowing guideline. Because this hairstyle emphasizes a three-dimensional look, we'll draw it in a three-quarter view rather than a profile or a front view, which are both flat.

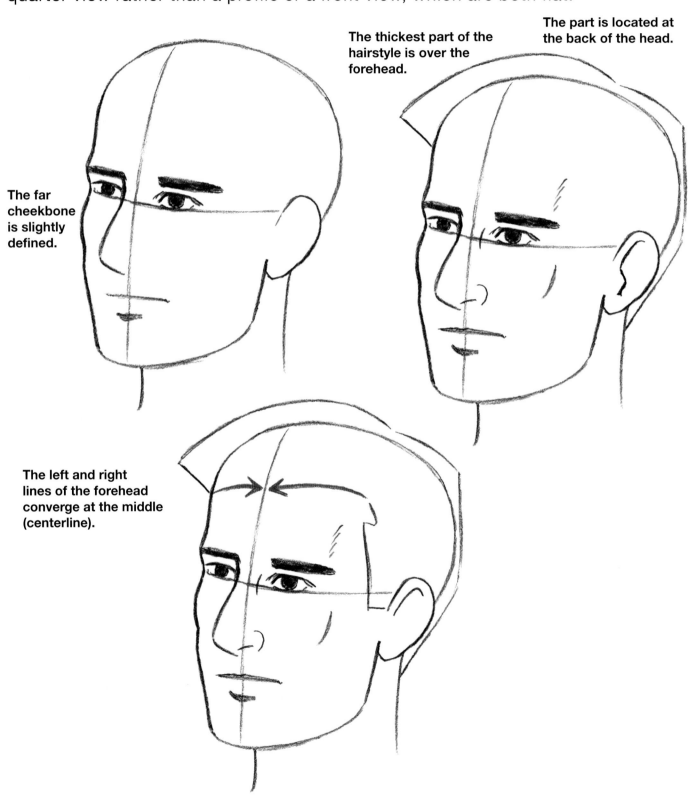

The thickest part of the hairstyle is over the forehead.

The part is located at the back of the head.

The far cheekbone is slightly defined.

The left and right lines of the forehead converge at the middle (centerline).

Draw a guideline in the form of a wave across the top. Leave a good amount of height underneath it, and shade it.

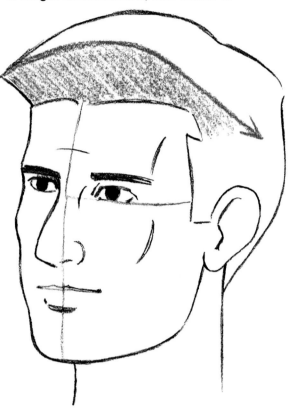

Shading Lines

Select areas of the face that stand out or that you want to emphasize, and draw small, repeated lines from each of those places for shading.

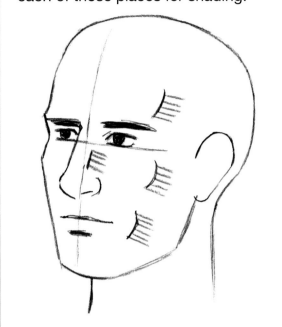

Shading the underside of the hair transforms the area into something solid looking.

Draw a few strands above the forehead, and angle them back so they appear to give direction to the haircut.

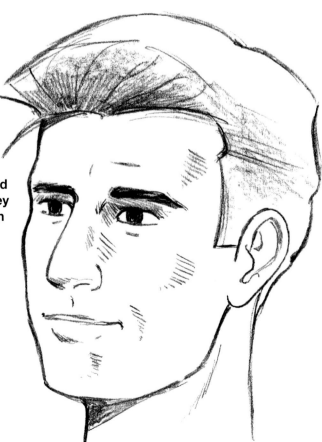

Hairline Types

The line where the hair meets the forehead can take different paths and create a variety of looks. Just being aware of this fact can help. Let's look at a few popular approaches.

Curved

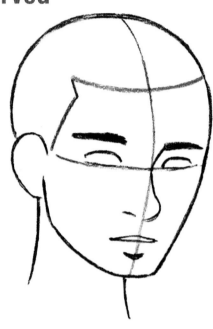

Straight

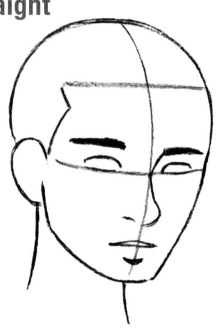

Wave

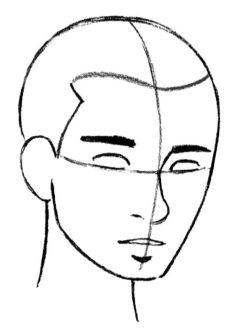

Converging Lines

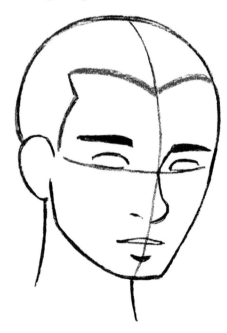

Straight Bangs

Straight bangs go well with metropolitan hairstyles. This is a sharp look that emphasizes vertical and horizontal lines. The hair is pulled behind the ears but still shows layers: one in front of the head and the other in back.

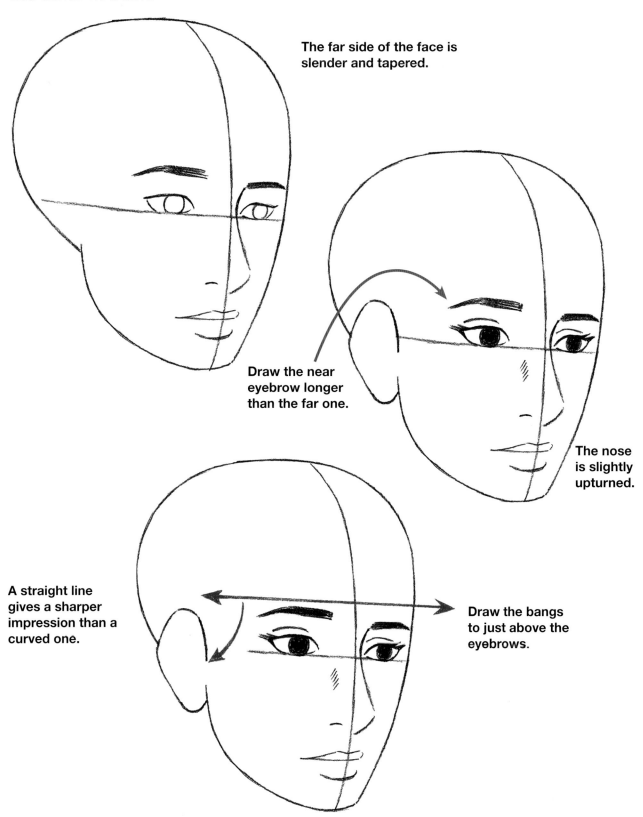

The far side of the face is slender and tapered.

Draw the near eyebrow longer than the far one.

The nose is slightly upturned.

A straight line gives a sharper impression than a curved one.

Draw the bangs to just above the eyebrows.

121

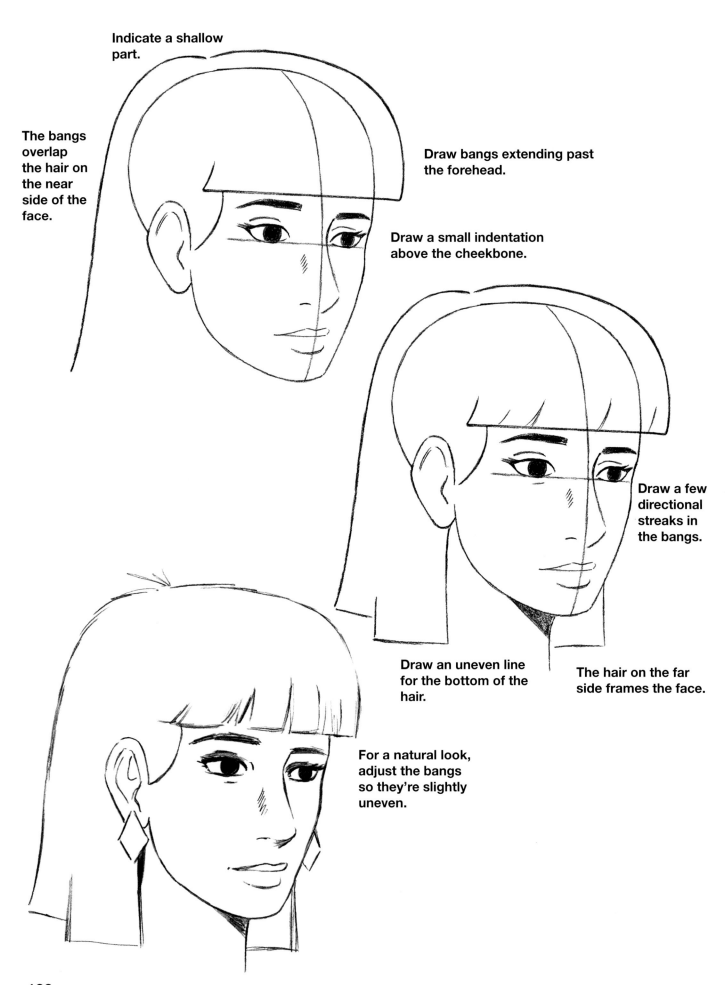

Indicate a shallow part.

The bangs overlap the hair on the near side of the face.

Draw bangs extending past the forehead.

Draw a small indentation above the cheekbone.

Draw a few directional streaks in the bangs.

Draw an uneven line for the bottom of the hair.

The hair on the far side frames the face.

For a natural look, adjust the bangs so they're slightly uneven.

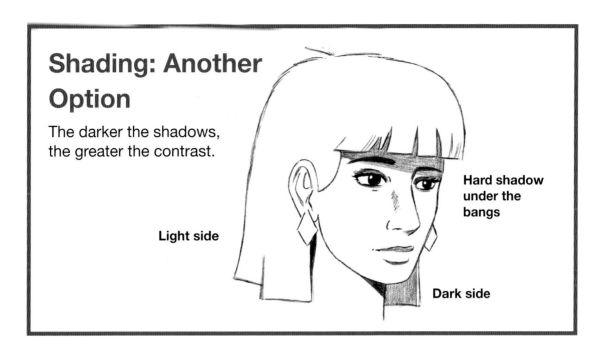

Shading: Another Option

The darker the shadows, the greater the contrast.

Light side

Hard shadow under the bangs

Dark side

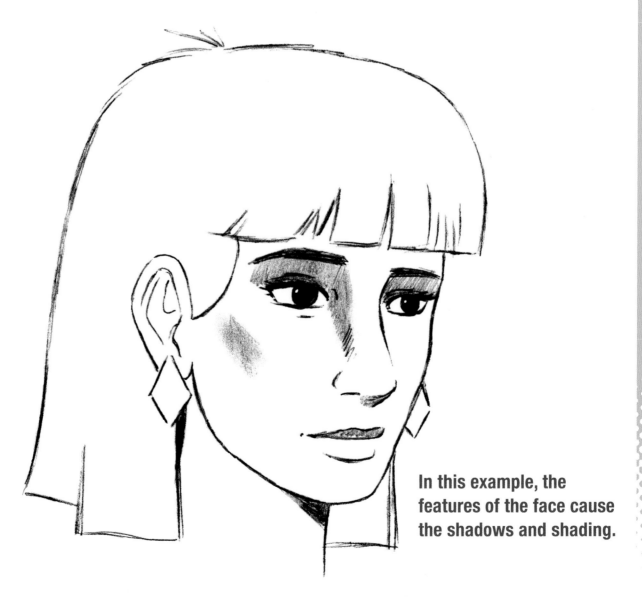

In this example, the features of the face cause the shadows and shading.

Bangs in Profile

Bangs are versatile. Long bangs work well with short hair, and short bangs work well with long hair. This youthful look is created with brushed bangs on top and gently flowing hair down the side.

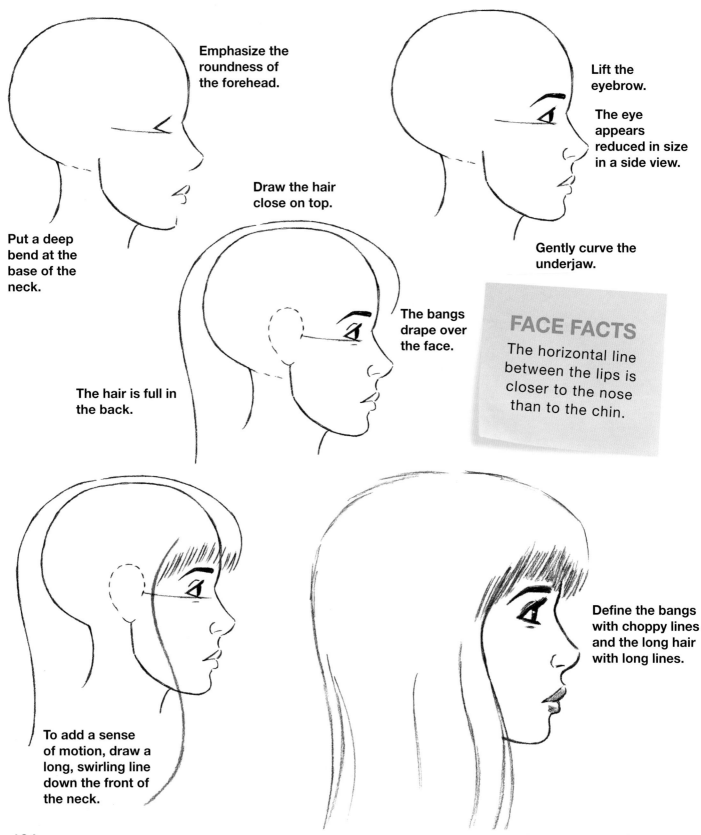

Emphasize the roundness of the forehead.

Lift the eyebrow.

The eye appears reduced in size in a side view.

Draw the hair close on top.

Put a deep bend at the base of the neck.

Gently curve the underjaw.

The bangs drape over the face.

FACE FACTS
The horizontal line between the lips is closer to the nose than to the chin.

The hair is full in the back.

To add a sense of motion, draw a long, swirling line down the front of the neck.

Define the bangs with choppy lines and the long hair with long lines.

Close Cut with Extended Top

This appealing style begins by closely following the shape of the head. With the foundation in place, we'll extend the top in order to individualize the look. Last, we'll build up the hair a little bit all around, to give it some padding. Hairstyles don't always happen in one fell swoop, but often as a series of small additions and changes.

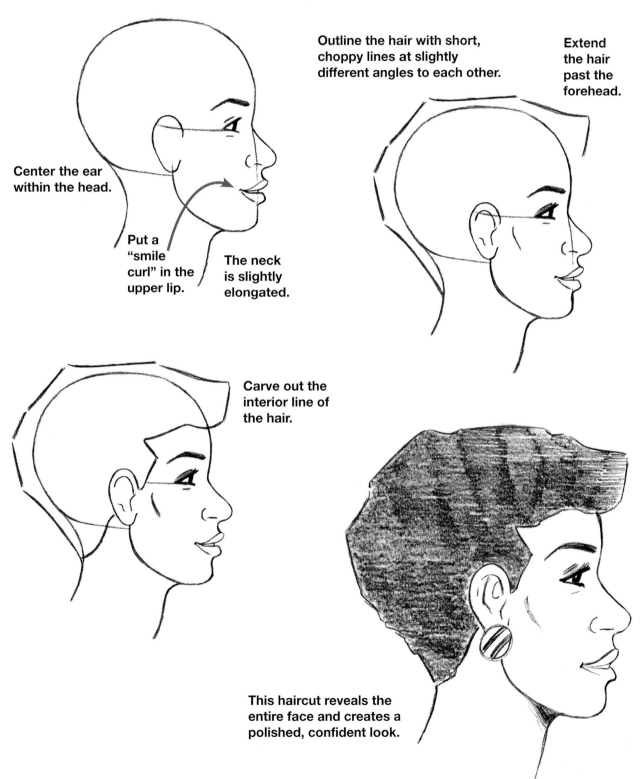

Center the ear within the head.

Put a "smile curl" in the upper lip.

The neck is slightly elongated.

Outline the hair with short, choppy lines at slightly different angles to each other.

Extend the hair past the forehead.

Carve out the interior line of the hair.

This haircut reveals the entire face and creates a polished, confident look.

Forward Flowing

This cut reminds me of a fountain springing up in the center part and flowing down both sides. By adding height to the middle part, you create a lively look. As it descends, the hair overlaps the face and frames it from behind. As a result, the picture looks composed and pleasing.

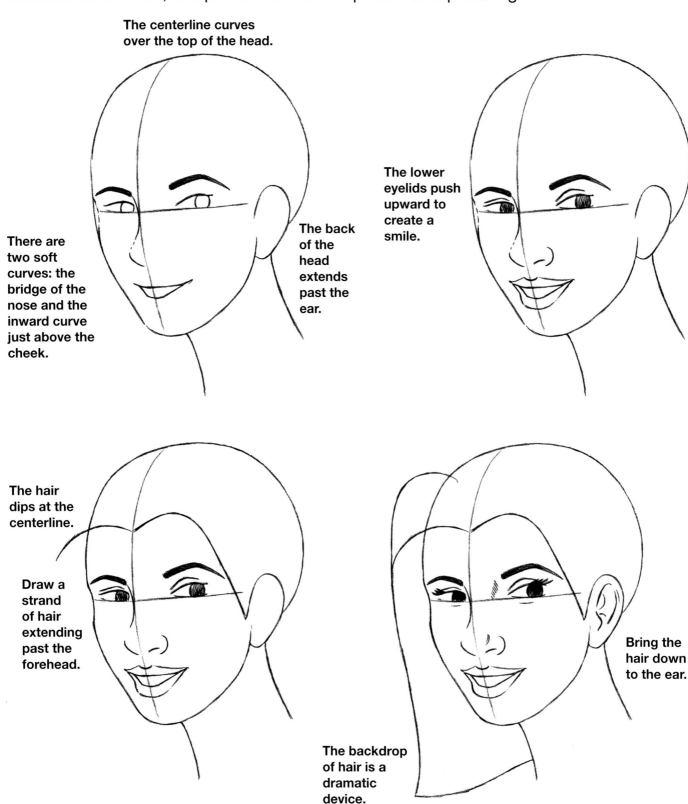

The centerline curves over the top of the head.

There are two soft curves: the bridge of the nose and the inward curve just above the cheek.

The back of the head extends past the ear.

The lower eyelids push upward to create a smile.

The hair dips at the centerline.

Draw a strand of hair extending past the forehead.

Bring the hair down to the ear.

The backdrop of hair is a dramatic device.

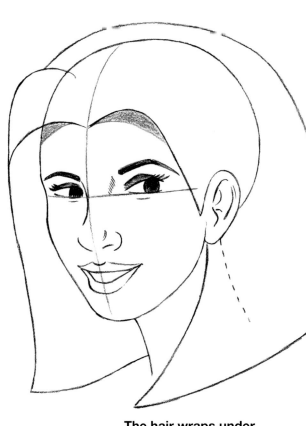

Shade the head below the arching strands of hair.

Define the middle part by drawing two waves on top.

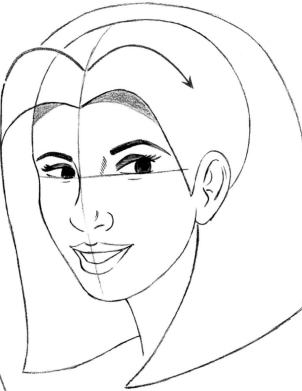

The hair wraps under the ear and curves forward, for a stylish look.

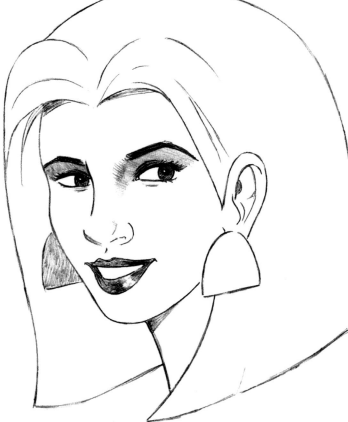

This hairstyle is dramatic. In order to maintain the prominence of the eyes, I decided to shade them, and in that way, keep them in the forefront.

Freestyle

Although many hairstyles with a middle part present a carefully crafted look, the middle part is also an excellent choice for hairstyles that burst with exuberance. The middle part frees the hair on either side to reach out, unrestrained.

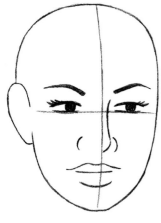

Draw thin and raised eyebrows.

The part splits the hair in different directions. But the lines are not symmetrical.

The more carefree the style, the more important it is to start with well-controlled guidelines.

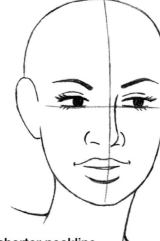

Eyelashes on the lower eyelids create a glittery look.

Draw a shorter neckline in back and a longer (stretched) one in front.

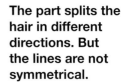

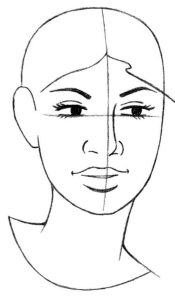

FACE FACTS
Remember that you don't have to make the curls and design on the left and right sides of the hairstyle completely symmetrical. Some variation looks more natural.

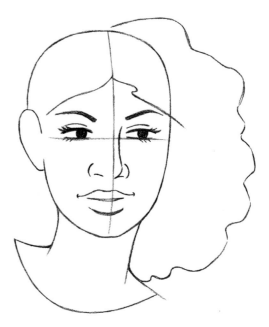

Be impromptu, but also follow a general path so the hair meets up with the other side and completes the haircut.

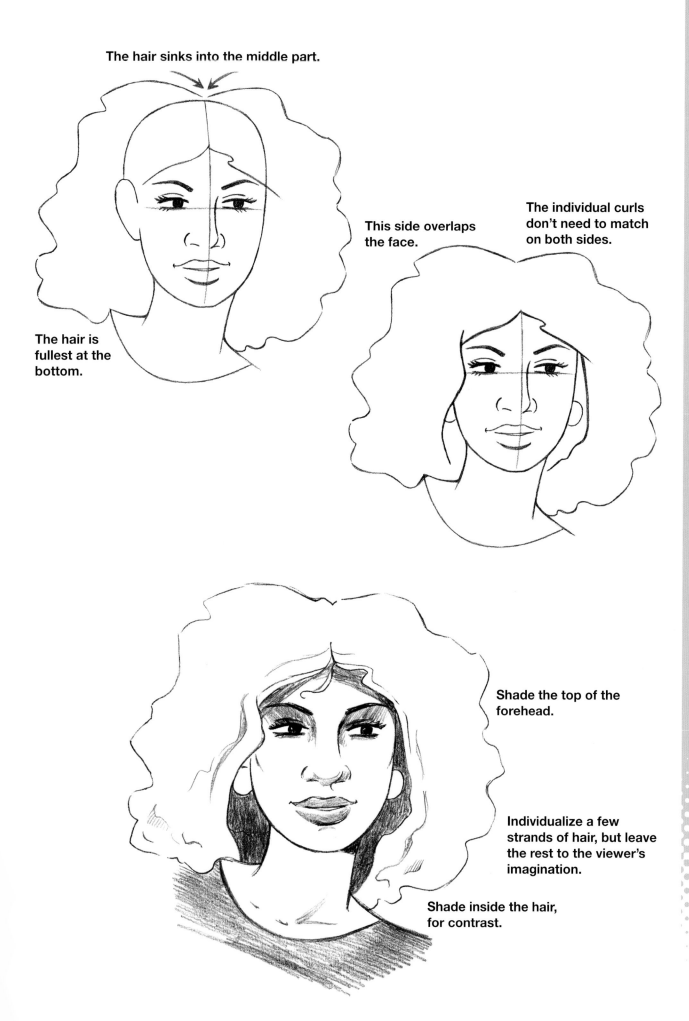

The hair sinks into the middle part.

The hair is fullest at the bottom.

This side overlaps the face.

The individual curls don't need to match on both sides.

Shade the top of the forehead.

Individualize a few strands of hair, but leave the rest to the viewer's imagination.

Shade inside the hair, for contrast.

Bangs & Ponytail

These bangs are open in the sense that there's no horizontal line drawn along the bottom. That creates a light and airy look. They also allow the dark eyebrows to peek through. Ponytails can be any shape, from straight to slightly curved, flipping up in back or winding around the neck and falling over the shoulder. The longer the ponytail, the more curves it can have.

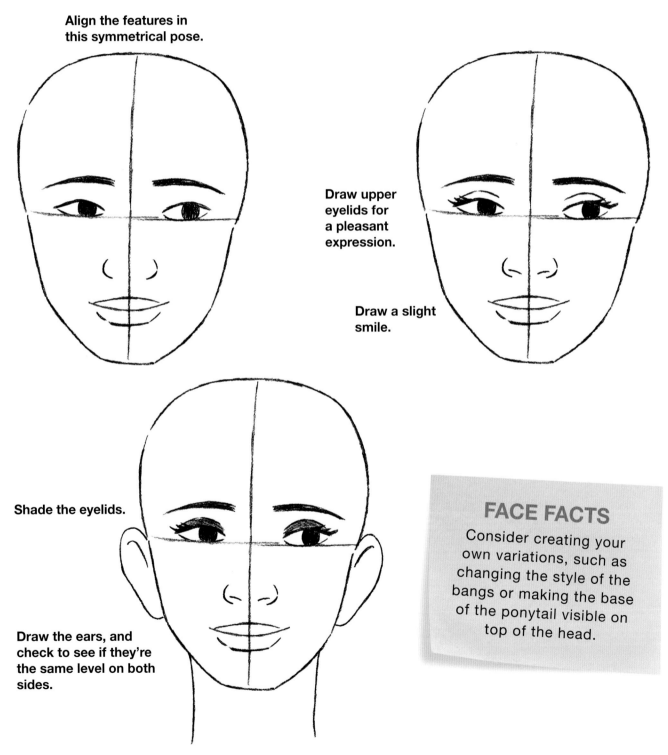

Align the features in this symmetrical pose.

Draw upper eyelids for a pleasant expression.

Draw a slight smile.

Shade the eyelids.

Draw the ears, and check to see if they're the same level on both sides.

FACE FACTS
Consider creating your own variations, such as changing the style of the bangs or making the base of the ponytail visible on top of the head.

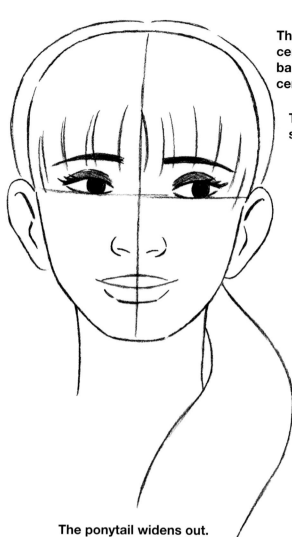

The bangs on the left of the centerline curve left. The bangs on the right of the centerline curve right.

The outline of the hair stays close to the head.

The ponytail widens out.

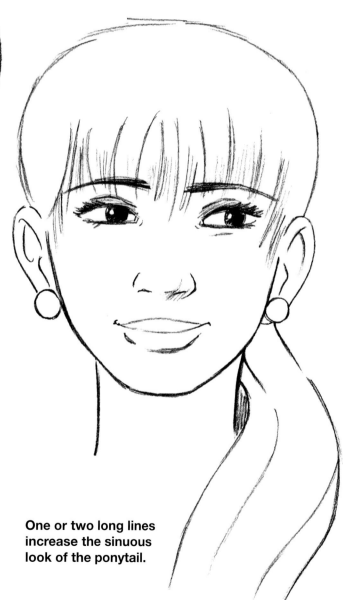

One or two long lines increase the sinuous look of the ponytail.

Brushed Back

The brushed back effect reveals the entire forehead. Hair travels over and around the head in a continuous line and ends with a flip, which provides a nice accent. In order to maintain a slick appearance, errant strands of hair have been eliminated. With this hairdo, everything is out in the open; nothing hides behind a layer of hair.

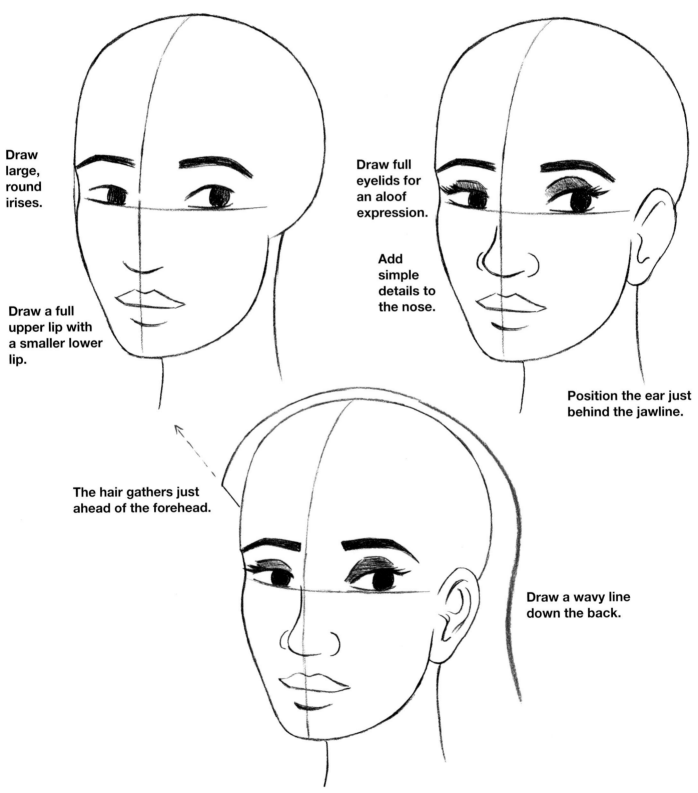

Draw large, round irises.

Draw a full upper lip with a smaller lower lip.

Draw full eyelids for an aloof expression.

Add simple details to the nose.

Position the ear just behind the jawline.

The hair gathers just ahead of the forehead.

Draw a wavy line down the back.

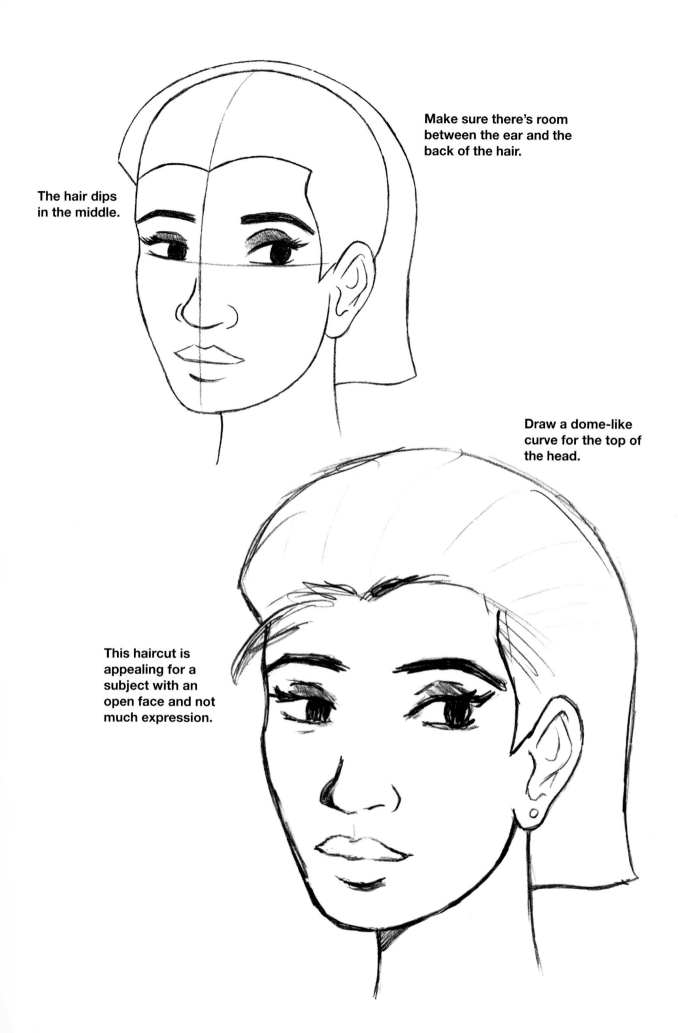

Make sure there's room between the ear and the back of the hair.

The hair dips in the middle.

Draw a dome-like curve for the top of the head.

This haircut is appealing for a subject with an open face and not much expression.

A Versatile Look

This hairstyle can be casual or dressy. It's whatever you want it to be. What I like about it is that it has a spontaneous energy. Squeezed in the middle by a headband, the back of the hair overflows. Since the structure is loose, it's easy and fun to draw.

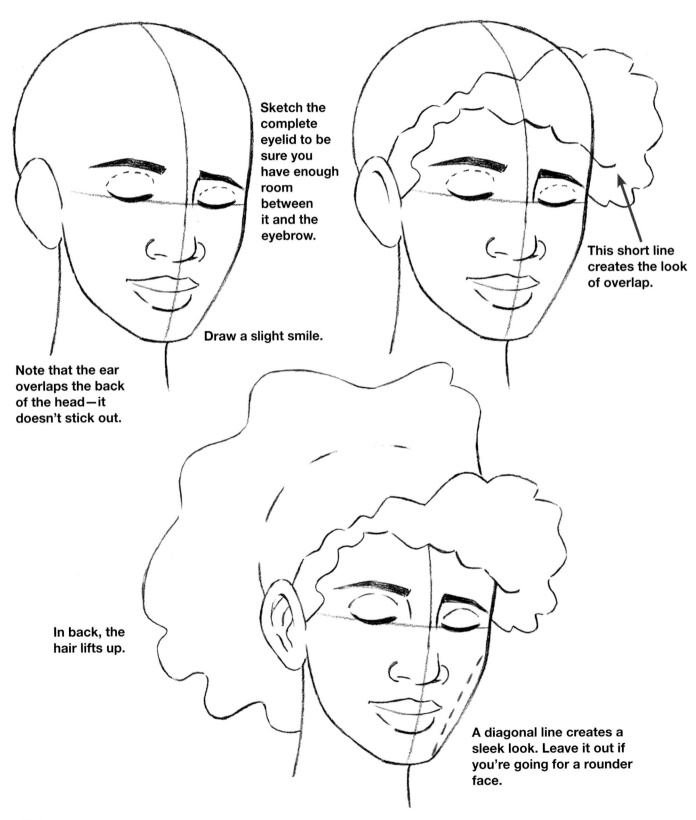

Sketch the complete eyelid to be sure you have enough room between it and the eyebrow.

Draw a slight smile.

Note that the ear overlaps the back of the head—it doesn't stick out.

This short line creates the look of overlap.

In back, the hair lifts up.

A diagonal line creates a sleek look. Leave it out if you're going for a rounder face.

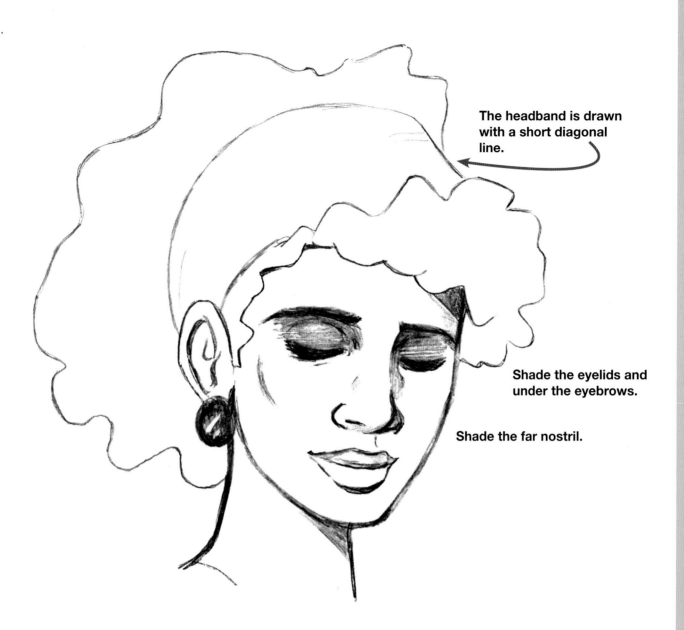

The headband is drawn with a short diagonal line.

Shade the eyelids and under the eyebrows.

Shade the far nostril.

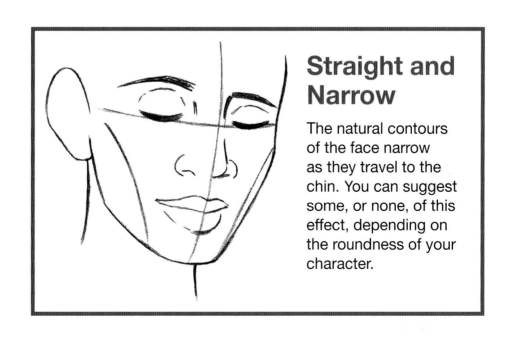

Straight and Narrow

The natural contours of the face narrow as they travel to the chin. You can suggest some, or none, of this effect, depending on the roundness of your character.

Hair & Momentum

When the head moves, the hair tends to move with it. Motion can make haircuts look more vibrant. For example, if the head leans to the right, the hair may swing to the right, too, making the image more dramatic. Let's check out how it works.

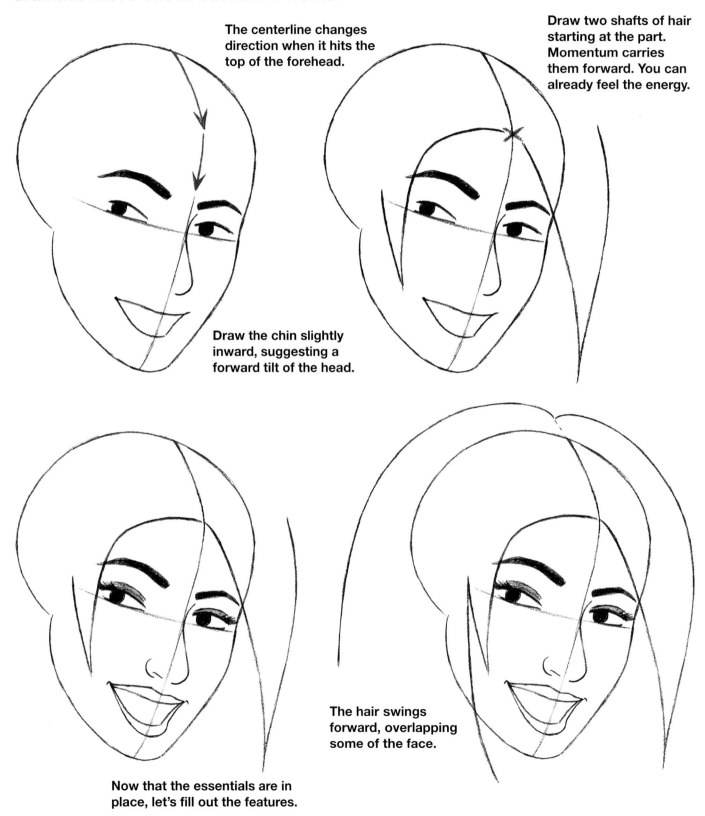

The centerline changes direction when it hits the top of the forehead.

Draw two shafts of hair starting at the part. Momentum carries them forward. You can already feel the energy.

Draw the chin slightly inward, suggesting a forward tilt of the head.

The hair swings forward, overlapping some of the face.

Now that the essentials are in place, let's fill out the features.

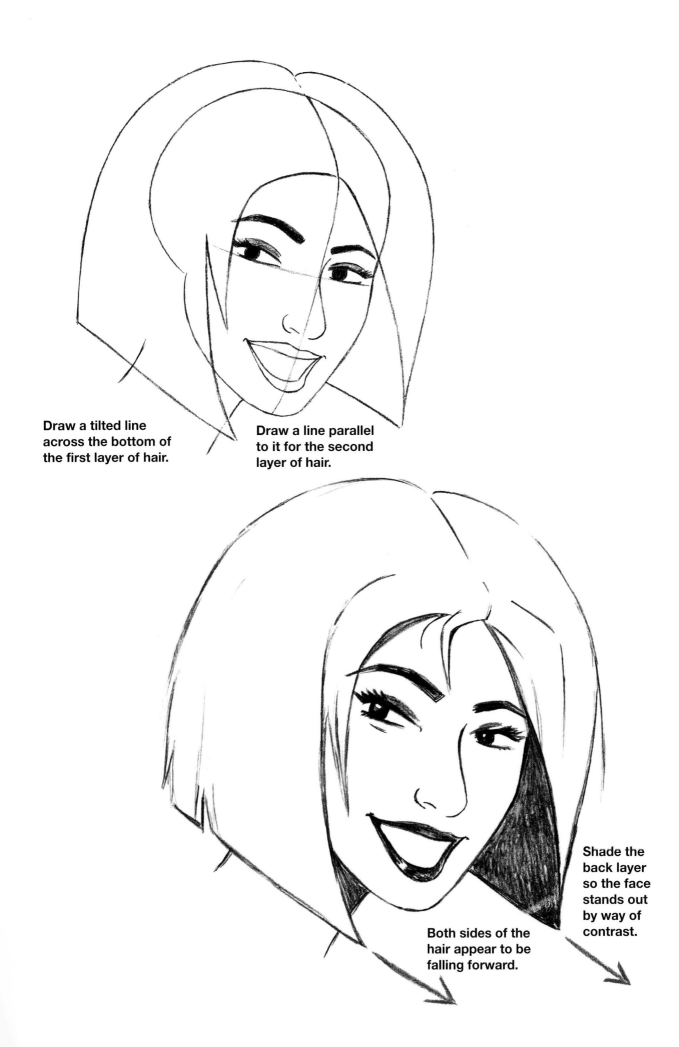

Draw a tilted line across the bottom of the first layer of hair.

Draw a line parallel to it for the second layer of hair.

Both sides of the hair appear to be falling forward.

Shade the back layer so the face stands out by way of contrast.

Flowing Strands

You can take an ordinary haircut and elevate it by simply adding two long strands of hair (provided that the haircut is full length). It's simple to draw because the strands mirror each other.

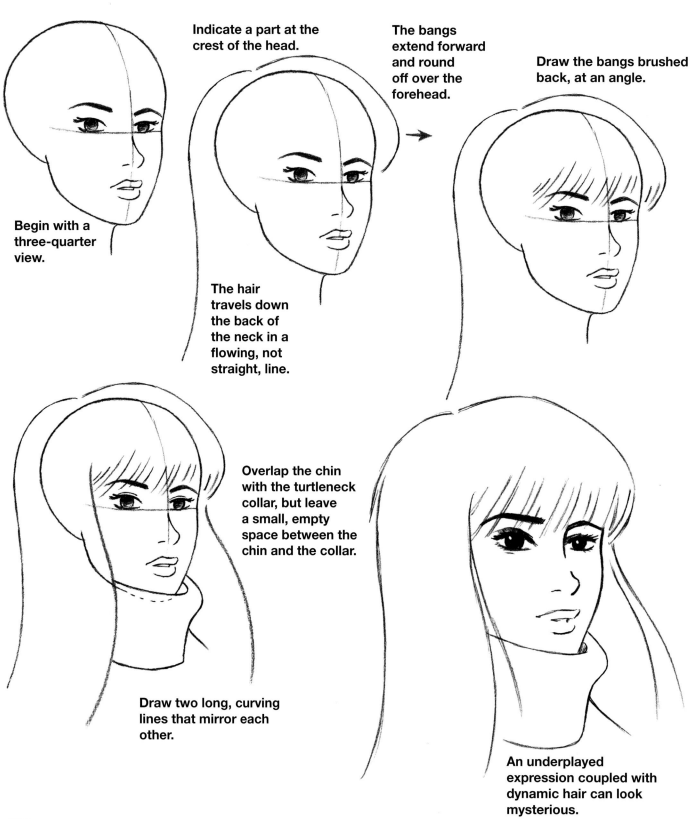

Begin with a three-quarter view.

Indicate a part at the crest of the head.

The hair travels down the back of the neck in a flowing, not straight, line.

The bangs extend forward and round off over the forehead.

Draw the bangs brushed back, at an angle.

Overlap the chin with the turtleneck collar, but leave a small, empty space between the chin and the collar.

Draw two long, curving lines that mirror each other.

An underplayed expression coupled with dynamic hair can look mysterious.

Short Hair with a Flip

Like some of the other approaches we've tried, this one uses a bit of strategy. Here, we have two elements: a hairstyle and glasses. If we put the emphasis on both, we may end up with the emphasis on neither. Shorter hair allows attention to be placed on the glasses.

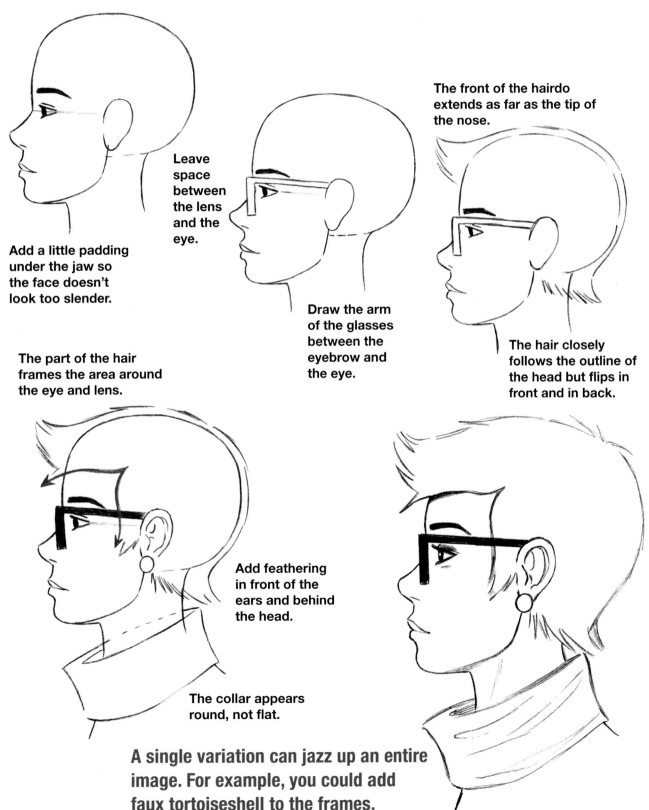

Add a little padding under the jaw so the face doesn't look too slender.

Leave space between the lens and the eye.

Draw the arm of the glasses between the eyebrow and the eye.

The front of the hairdo extends as far as the tip of the nose.

The hair closely follows the outline of the head but flips in front and in back.

The part of the hair frames the area around the eye and lens.

Add feathering in front of the ears and behind the head.

The collar appears round, not flat.

A single variation can jazz up an entire image. For example, you could add faux tortoiseshell to the frames.

139

Blunt Cut

This is a good alternative to other short cuts. The design is somewhat abrupt due to the horizontal "blunt" bottom of the hair. It doesn't flip up or swing forward. Its main feature is a diagonal line that stretches from the forehead to the ear, and then down the neck. This haircut brushes the hair over the ear rather than behind.

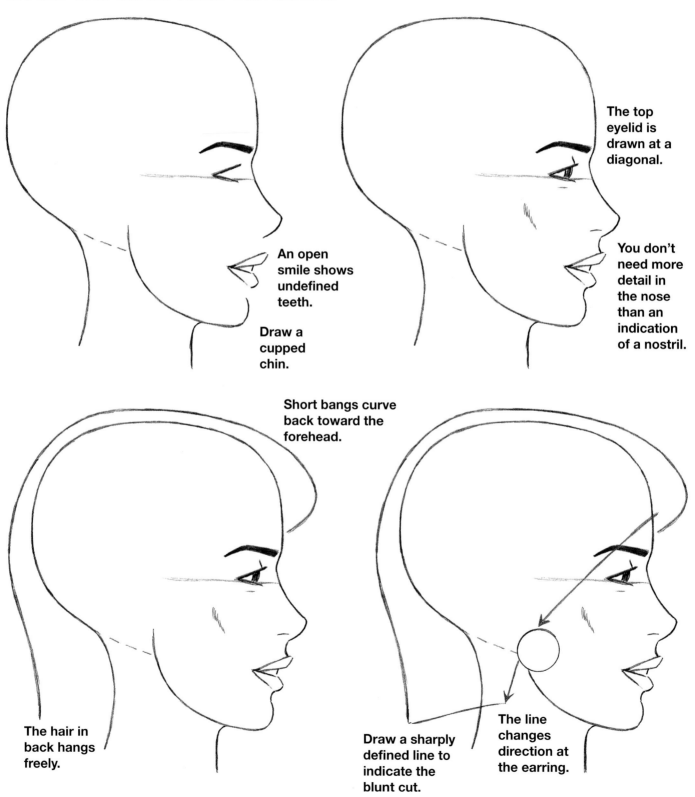

An open smile shows undefined teeth.

Draw a cupped chin.

The top eyelid is drawn at a diagonal.

You don't need more detail in the nose than an indication of a nostril.

Short bangs curve back toward the forehead.

The hair in back hangs freely.

Draw a sharply defined line to indicate the blunt cut.

The line changes direction at the earring.

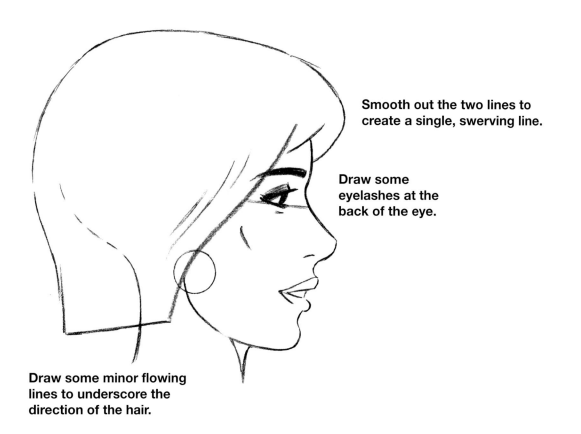

Smooth out the two lines to create a single, swerving line.

Draw some eyelashes at the back of the eye.

Draw some minor flowing lines to underscore the direction of the hair.

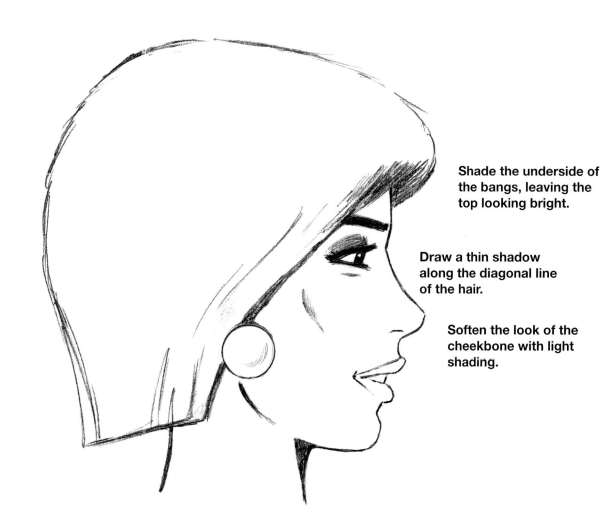

Shade the underside of the bangs, leaving the top looking bright.

Draw a thin shadow along the diagonal line of the hair.

Soften the look of the cheekbone with light shading.

Close Cut

This hairstyle gets its appeal from the roundness of the head, which it follows closely. You could draw the boundary of the hair on the forehead either higher or lower. You could make it rounder or flatter. But the height of the hair should remain uniform on the top and on the sides.

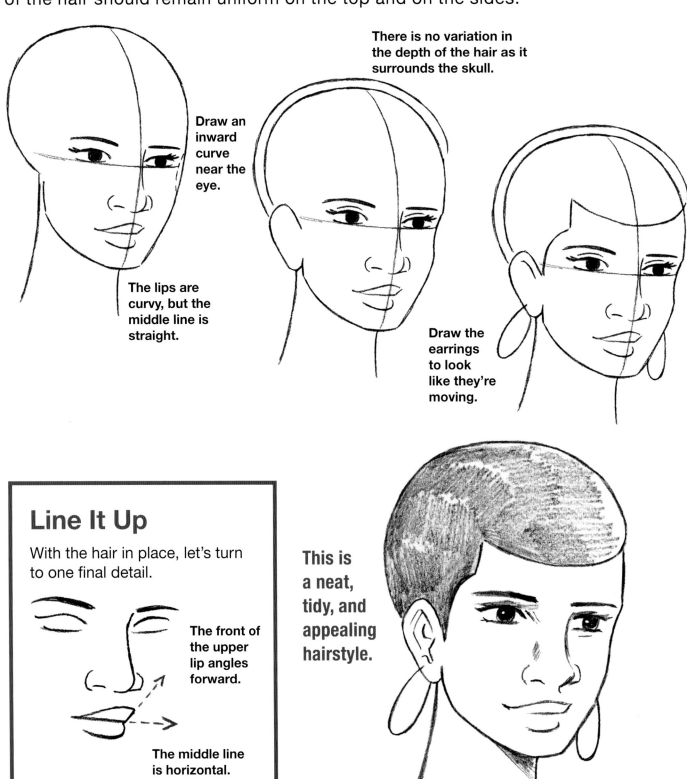

Draw an inward curve near the eye.

The lips are curvy, but the middle line is straight.

There is no variation in the depth of the hair as it surrounds the skull.

Draw the earrings to look like they're moving.

Line It Up

With the hair in place, let's turn to one final detail.

The front of the upper lip angles forward.

The middle line is horizontal.

This is a neat, tidy, and appealing hairstyle.

Index

Don't Miss These Other Great Titles
from Christopher Hart!

More from the best-selling **Figure It Out!** series.

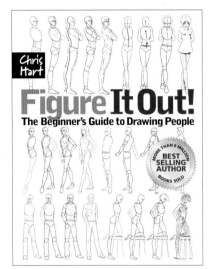

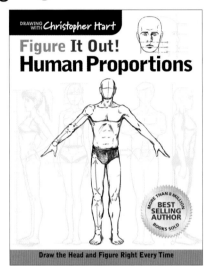

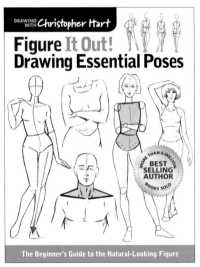

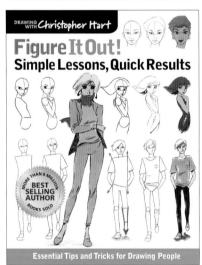

Expert instruction on anime, cartooning, and more!

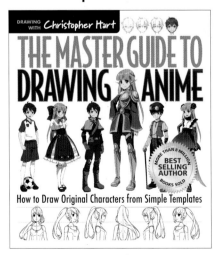

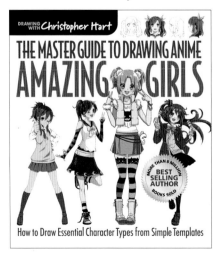

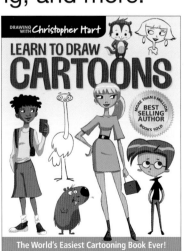

Get Creative 6